N
8214.5
.U6
T46
1994

Thomas Gilcrease
 Institute of
 American History and

Treasures of the Old
 West.

$17.98

DATE			

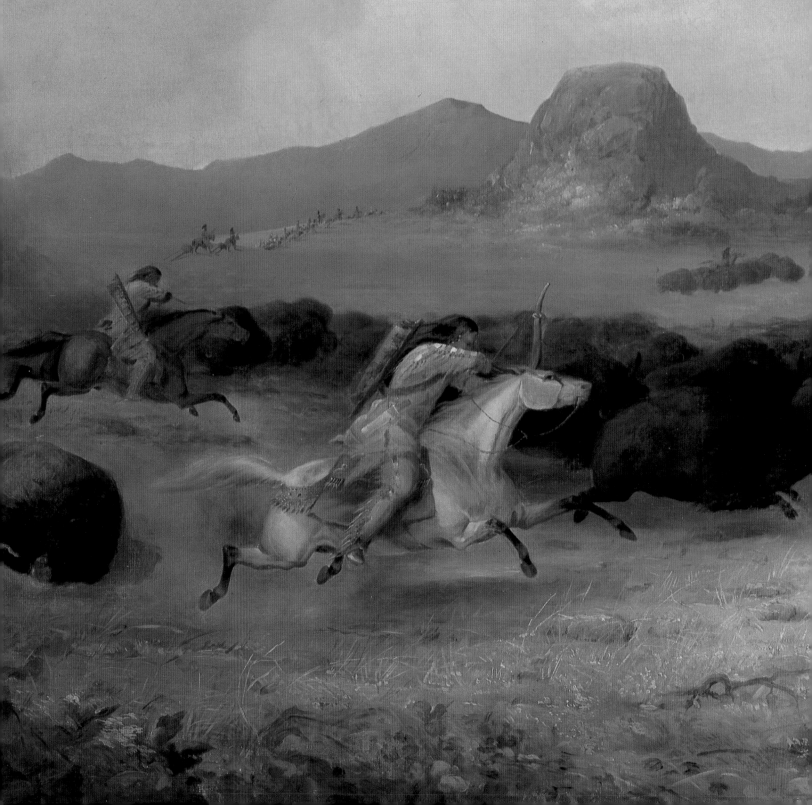

Paintings and Sculpture from the Thomas
TREASURES OF

Peter H. Hassrick

Gilcrease Institute of American History and Art
THE OLD WEST

Abradale Press

Harry N. Abrams, Inc.,

Publishers

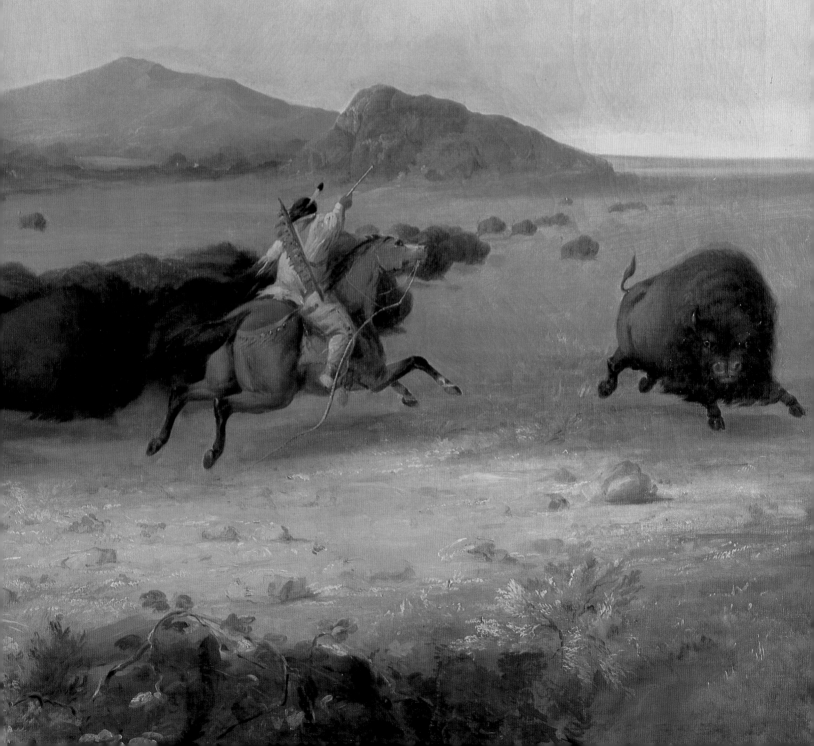

To the Memory of Thomas Gilcrease

Published in connection with an exhibition
in 1984 at the Denver Art Museum and
the Buffalo Bill Historical Center
in Cody, Wyoming

Project Manager: Margaret L. Kaplan
Editor: Joan E. Fisher
Designer: Robert McKee

Library of Congress Cataloging-in-Publication Data
Thomas Gilcrease Institute of American History and Art.
Treasures of the Old West: paintings and sculpture from the
Thomas Gilcrease Institute of American History
and Art/Peter H. Hassrick.
p. cm.
Includes bibliographical references and index.
ISBN 0–8109–8133–5
1. West (U.S.) in art — Catalogs. 2. Indians of North America —
Pictorial works — Catalogs. 3. Art, American — Catalogs.
4. Art — Oklahoma — Tulsa — Catalogs. 5. Thomas Gilcrease
Institiute of American History and Art — Catalogs.
I. Hassrick, Peter H. II. Title.
[N8214.5.U6T46 1994]
758'.9978'007476686 — dc20 93–20836
 CIP

Illustrations © 1984 The Thomas Gilcrease Institute
of American History and Art

This 1994 edition is published by
Harry N. Abrams, Incorporated, New York.
A Times Mirror Company.

Printed and bound in China

ALL PHOTOGRAPHY IN THIS BOOK IS BY MARK HAYNES.

CONTENTS

ACKNOWLEDGMENTS

Thomas Gilcrease spent over half his lifetime assembling a huge inventory of art, artifacts, and documents that would chronicle the vast range of human experience in North America. The result of this labor of love was an unparalleled collection touching on virtually every aspect of our nation's growth. But Gilcrease's personal heritage and pride in his Native American ancestry gave a focus to his collecting that now makes the Thomas Gilcrease Institute of American History and Art our country's finest repository of the art of the Old West. So extensive are its resources that the current exhibition, as rich as it is, can only suggest its full abundance.

The selection offered on the occasion is, however, particularly substantial, for it has been shaped by the desire to illuminate two major sources of inspiration for generations of American artists—the people and the land. Here frontier life unfolds in all its exciting multiplicity in narrative paintings that capture the spirit of an expanding and expansive nation. Complementing these dramatic vignettes of human struggle and endurance are vivid portraits of the land itself, overwhelming in the intensity of its beauty and power.

In an age of dwindling resources, it is especially fitting to celebrate this vanished world of plenty, of seemingly limitless human and material wealth. The exhibition offers more than a nostalgic record of our lost past. In it we can find clues to our present and cautionary lessons for our future. Indeed, the exhibition's very existence stands as proof of the continued vitality of the cooperative impulse that has marked all successful human endeavor. It is this age-old spirit of cooperation that has motivated our three institutions to join forces in bringing to the people of Colorado and Wyoming a great, truly unique resource.

Special thanks must be extended to William C. Foxley, Trustee of the Denver Art Museum and the Buffalo Bill Historical Center, for his assistance in negotiating the loan of the exhibition and in the selection of works included. We also acknowledge the welcome assistance of the Thomas Gilcrease Museum Association in sponsoring such special projects. Fred Myers, Director of the Gilcrease Museum, has given untiringly of his help, cooperation, and encouragement. His staff, including Dan McPike, Anne Morand, Sarah Hirsch, Jeanne Snodgrass King, and Mark Haynes, has provided invaluable assistance at all stages of the project. In addition, Mary Ann Igna and L. Anthony Wright of the Denver Art Museum, and Debbi Stambaugh, Kathy Heaton, Paul Fees, Michael Kelly, and Judie Schmidlapp of the Buffalo Bill Historical Center staff have helped bring this publication and the accompanying exhibition to fruition.

LEWIS W. STORY
Denver Art Museum

PETER H. HASSRICK
Buffalo Bill Historical Center

FOREWORD

The Thomas Gilcrease Institute of American History and Art, although it is typical of museums in America, is remarkable in several ways—that it is located in Tulsa, Oklahoma; that it is based almost entirely on the collection of one man; that it became a municipal museum by choice of its city. The collection of the museum, which is generally recognized to be the largest and most varied collection anywhere of North American Indian and Western material, was acquired by Thomas Gilcrease in the amazingly short span of two decades, during the 1940s and 50s. Composed of more than 8,000 artworks, 41,000 Indian artifacts, and 81,000 archival and library items, the collection documents Mr. Gilcrease's view of American history.

The collection shows the richness and variety of Indian culture in North America, and its underlying theme is the change wrought on the land and in Indian life as European cultures gained a foothold on the coasts and then expanded across the continent. Cultural rather than esthetic history is the touchstone of the collection.

That the collection is housed in Tulsa is, of course, a function of the life of the collector. Thomas Gilcrease was born in Louisiana before Oklahoma was a state. He was the oldest son of a farm family that moved just after the turn of the century to Indian Territory to take advantage of the tribal lands available to them because of their Creek Indian ancestry. While Tom Gilcrease was still a young man, he received an allotment of land that shortly proved to be rich in oil, the beginning of his business success and his lifelong pursuit of learning.

Sometime in the 1930s, while traveling in Europe, Gilcrease conceived the idea of putting together a collection, a la great European treasure houses, for his native region. The theme would be the American story from the viewpoint of the Western frontier.

The other important element in the founding of the museum is that the citizens of Tulsa voted in the mid-'50s to place an extra tax on themselves to "save the Gilcrease collection for Tulsa." Gilcrease had opened a small private museum in the late house in northwest Tulsa. By the early fifties, with oil selling financially strapped by the collection and its maintenance. se of a true collector, that his collection not be dispersed, he uiries about selling it in such foreign quarters as Texas. The ized some Tulsa citizens into the action that led to a successful subsequent acquisition of the collection by the city.

death in 1962, bequeathed the remainder of the collection to ly made arrangements that income from his oil properties assuring the museum. And so, the Gilcrease Institute of American History and Art continues—a municipal museum based on the collecting activity of one man, subsequently aided in outreach by the support of the Thomas Gilcrease Museum Association. Until recently it was necessary to visit Tulsa to get any idea of the character and extent of the collection. Now this publication and several others, as well as traveling exhibitions, have begun to make the collection known to a wider audience. Thomas Gilcrease and his collection are no longer exclusively a Tulsa treasure.

FRED A. MYERS, Director, Thomas Gilcrease Institute
of American History and Art

TREASURES OF

Paintings and Sculpture from the Thomas

The collection of the Thomas Gilcrease Institute of American History and Art affords a unique perspective on the development of American art. With primary focus on themes related to the Far West, the paintings and bronzes comprising this celebrated Tulsa collection provide an unequaled view of two fundamental forces that energized the visual expression of the nineteenth and early twentieth centuries: the narrative and landscape traditions.

The narrative tradition, which appeared firmly in American art from the early 1800s, revealed elemental truths about the American experience through the fabric of history and everyday life. It was through Western themes that this tradition enjoyed some of its richest application in American painting and sculpture. These themes corresponded essentially with the evolving frontiers and included exploration, early trade, Indians (as recorded, confronted, exploited, and ultimately decimated), transportation, cattle, and settlement. As they echoed the changing scene in the West, with the inherent promise recognized in the frontier itself, they also reflected the image of America as an emerging nation.

A decade has now passed since two pivotal museum exhibitions brought to our attention the importance of the narrative tradition in American art. In 1974 the Whitney Museum of American Art hosted an exhibition entitled *The Painter's*

THE OLD WEST

Gilcrease Institute of American History and Art

America: Rural and Urban Life. That same year, the Los Angeles County Museum of Art presented *American Narrative Painting.* The Whitney show was nicely coherent, relating art as a reflection of cultural and social ideals. It concentrated on the genre element, scenes from everyday life. The Los Angeles exhibition was more encyclopedic and included history painting and religious subjects as well as the everyday and secular. An aspect they both neglected, however, was one of the most pervasive American themes in the narrative tradition—the West. The omission is somewhat ironic, as there has always been something about the narrative art of the West which, as Henry Tuckerman observed about Charles Deas's work, has a "peculiar 'native American' zest"[1] to it.

In receiving recognition for its place within the mainstream of American art, the Western landscape tradition has fared much better. Without having seen them, James Fenimore Cooper speculated in the mid-nineteenth century that "the Rocky Mountains . . . must possess many noble views." He complained that historic "accessories are necessarily wanting" but that, after all, "a union of art and nature can alone render scenery perfect."[2] Since America had neither classical heritage nor ruined vestiges of past glories or civilization to proclaim, only a special sense of place, of untrammeled wilderness, could substitute and foster the notion of national promise. The Western landscape offered the full complement of

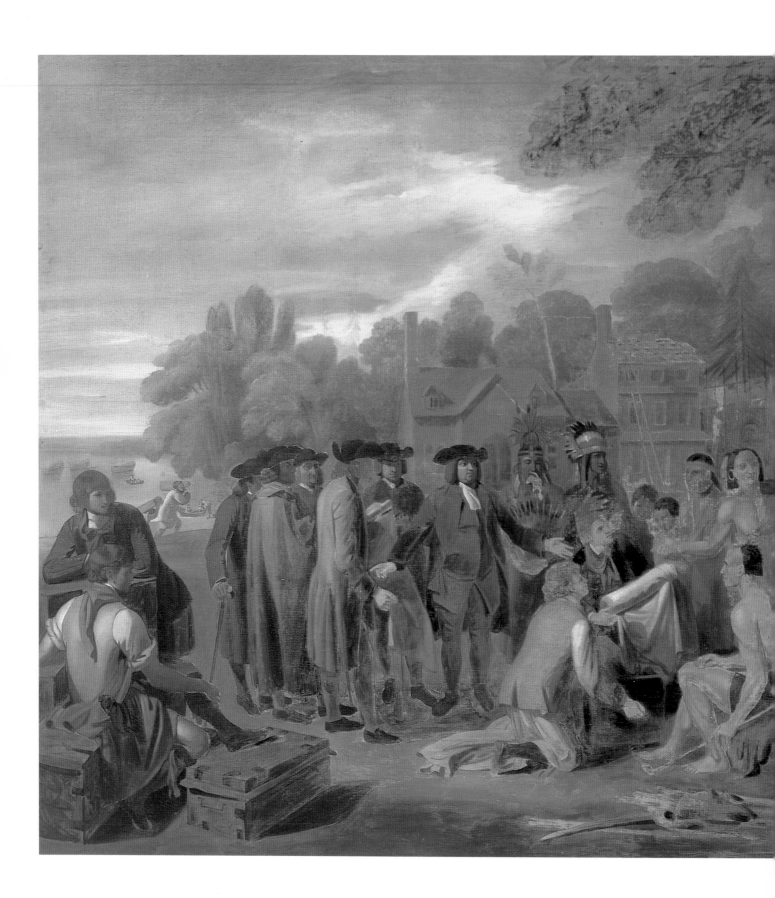

plate 1
Benjamin West
Penn's Treaty with the Indians
c. 1771. Oil on canvas, 74 x 107½". 0126.1021

The act of painting has powers to dignify man, by transmitting to posterity his noble actions, and his mental powers, to be viewed in those invaluable lessons of religion, love of country, and morality: such subjects are worthy of the pencil, they are worthy of being placed in view as the most instructive records to a rising generation.

Benjamin West, from a letter
to Charles Willson Peale (1809)

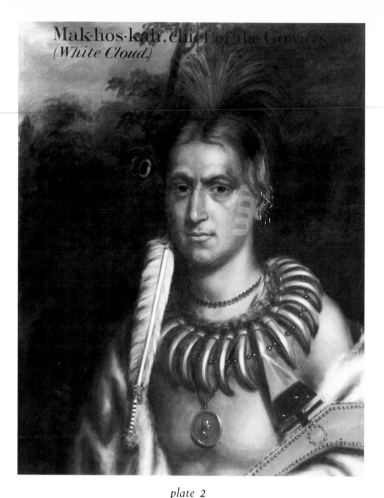

plate 2
Charles Bird King
Mak-hos-kah, Chief of the Gowyas (White Cloud). *1825. Oil on wood, 17 x 14". 0126.1198*

requisites. Walt Whitman even wondered if this remarkable landscape might someday provide a gauge for America's artistic self-realization:

The pure breath, primitiveness, boundless prodigality and amplitude, strange mixture of delicacy and power, of continence, of real and ideal . . . of these prairies, the Rocky Mountains, and of the Mississippi and Missouri Rivers—will they ever appear in, and in some sort form a standard for our poetry and art?[3]

This was accomplished, to some extent, in Whitman's lifetime as indicated by the national and even international celebrity of his contemporaries Albert Bierstadt and Thomas Moran. Today the Western landscape tradition has founded a firm place within American art history.[4]

Through the turn of the century, the disciplines of landscape and narrative art vied for ascendancy. There were occasions such as in 1863 when the two carried equal force. In that year Bierstadt exhibited his monumental tour de force, *The Rocky Mountains*, while Emanuel Leutze completed his epic painted version of

plate 3
Charles Bird King
Hayne Hudjihini, Eagle of Delight. *1825. Oil on wood, 17 x 14". 0126.222*

Westward the Course of Empire Takes Its Way for the United States Capitol Building. There were also such artists as Alfred Jacob Miller who in their work held an equal enthusiasm for landscape and for anecdote. And there was Frederic Remington, who, in his later career, went West solely to study the landscape and quality of light, then returned to his New York studio to fill in the figures that recounted some frontier saga. Yet for the most part, the two disciplines remained distinct, with man moving in and out of the landscape picture according to the popular taste of the times. It is the development of these two forces and their alternating ebb and flow that are so markedly demonstrated by the depth and quality of the Gilcrease collection.

*　　*　　*

American narrative painting emerged from the marbled strictures of classicism during the closing decades of the eighteenth century. Even before Jacques Louis David would elevate the moral and allegorical banner of antiquity to a level of creative anthem for French art, a Pennsylvania-born painter living in London amid the court of George III would rise as one of the earliest neoclassical painters

We saw him in Washington in 1821, whither he was
sent as one of a deputation from his tribe, to trans-
act business with the Government. He was dressed,
so far as his half-length discloses it, precisely as he
is seen in the portrait. He wore a head-dress of the
feathers of the war eagle, which extended, in a dou-
ble series, down his back to his hips, narrowing as
it descended. His robe was thrown carelessly but
gracefully over his shoulders, leaving his breast,
and often one arm bare.

Thomas McKenney and James Hall,
from The Indian Tribes of North America *(1836)*

On our arrival at Washington, we called to see our
Great Father, the President [Andrew Jackson]. He
looks as if he had seen as many winters as I have,
and seems to be a great brave! I had very little talk
with him, as he appeared to be busy, and did not
seem to be much disposed to talk. . . . He said he
wished to know the cause of my going to war
against his white children. I thought he ought to
have known this before; and, consequently, said
but little to him about it — as I expected he knew as
well as I could tell him.

From Life of Ma-Ka-Tai-Me-She-Kia-Kick
or Black Hawk . . . *(1834)*

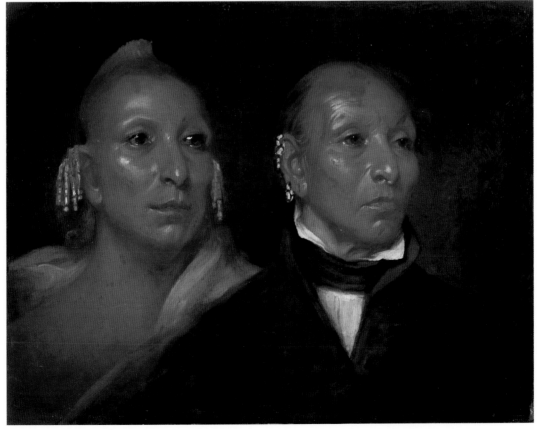

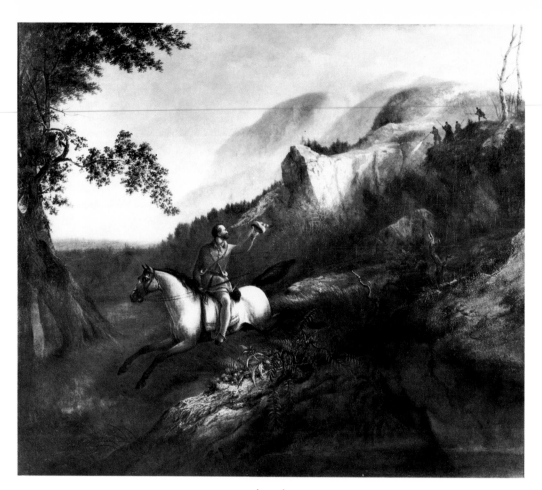

of historical subject matter. In 1770 the expatriate Benjamin West surprised the world with a courageous new statement in grand manner histrionics—a painting entitled *The Death of General Wolfe.* It was a testament to the heroics of recent rather than ancient events, and it focused attention on detail rather than generalization. Both notions were counter to the standards of the Royal Academy of Arts, as espoused by its president, Sir Joshua Reynolds. West's depiction of America's embattled frontier was vulgar to Reynolds, who claimed "the classical costume of antiquity much more becoming the inherent greatness of his subject than the modern garb of war."[5] West's figures were draped not in Roman togas but attired in the military uniforms of the day.

A year later, West would produce an equally innovative work, *Penn's Treaty with the Indians*[6] (plate 1). It was an idealized classical composition revealing the rather formal and static frieze of figures that might be expected from the brush of a young academician. The scene represented a grand moral truth unfolded within the frontier epoch of the New World—that conflict could find peaceful solution through rational behavior. It was set among plain surroundings as if to suggest a sense of genre, yet the figures are idealized, especially the Indians. West had once

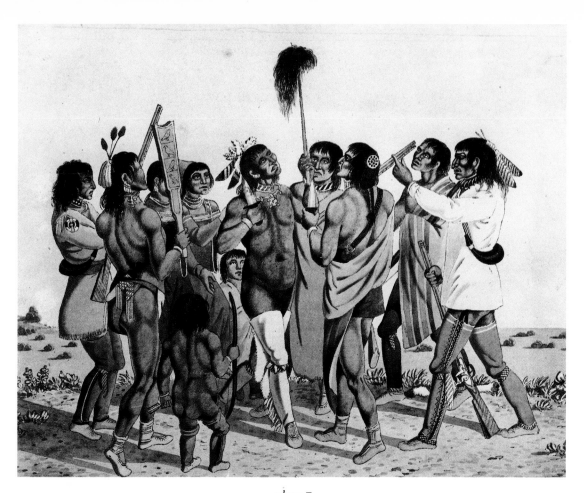

plate 7
Peter Rindisbacher
Introducing the Scalp. *c. 1825. Watercolor on paper, 7¼ x 8¾". 0226.1340*

compared the Apollo Belvedere to a Mohawk Indian, and now the artist portrayed the Indians in classical pose as avatars of antiquity.

In his painting of Penn's frontier diplomacy, West also sustained the perception of the American Indian as "noble savage," a notion that had emerged with some force in the mid-eighteenth century. Even though draped in ancient robes and portrayed with Greek profiles, the Indians represent a contemporary dying race that had once flourished in a pure state of nature. Just over Penn's shoulder, the ordered architecture of civilization begins to intrude. The primary Indian figures in the story, Lapowinsa and Tishcohan, evidence a hint of confused despair while Penn's gesture suggests the inevitability of the impending transformation.

Like Henri Rousseau, who conjured up ideal societies in faraway corners of the earth, West was allowed his interpretation of the Indian, to some degree at least, because he was physically removed from America. In London there was no fear of the Indian. Back home, however, the painters were less confident, and their attentions focused on society portraits. It was not until comfortably within the nineteenth century that either the Indian or the wilderness would be artistically celebrated by American painters.

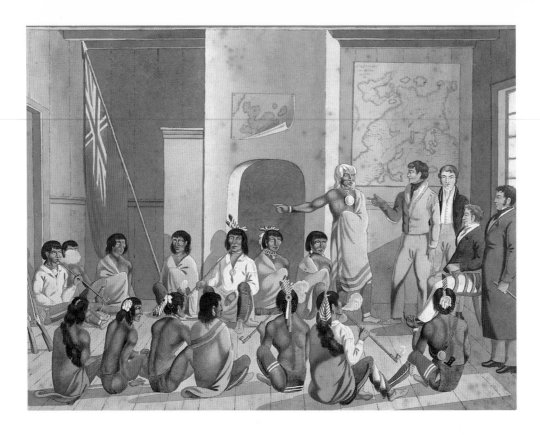

The artist whose name is Rindisbacher, is a young man, and has lived since early youth in our *western wilds*. He is perfectly acquainted with the subject of his very successful effort; and has, the writer of this is informed, in his portfolio, views of many of the finest scenes in that part of the country, whose *untamed wilderness* has never before furnished subjects for the pencil or the burin.

From The American Turf Register. . . *(1830)*

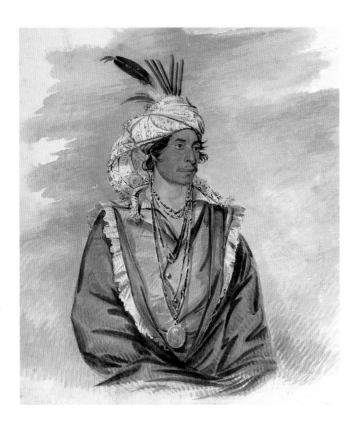

Man, in the simplicity and loftiness of his nature, unrestrained and unfettered by the disguises of art, is surely the most beautiful model for the painter, and the country from which he hails is unquestionably the best study or school of the arts in the world; such I am sure, from the models I have seen, is the wilderness of North America.

George Catlin, from Letters and Notes on. . .
the North American Indians *(1844)*

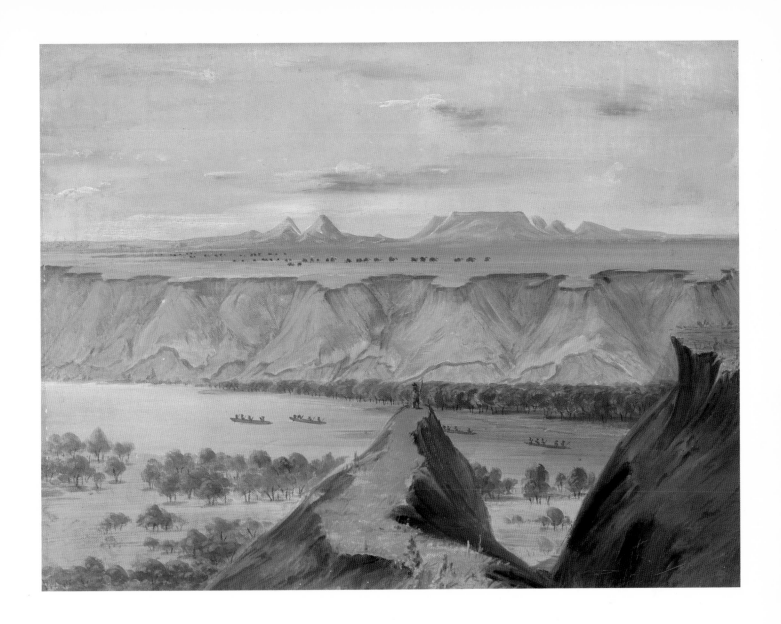

plate 10
George Catlin
View in the "Grand Detour"
1852. Oil on canvas, 11 ⅛ x 14¾". 0176.2132

Scarcely anything in nature can be found, I am sure, more exceedingly picturesque than the view from this place; exhibiting the wonderful manner in which the gorges of the river have cut out its deep channel through these walls of clay on either side, of two or three hundred feet in elevation; and the imposing features of the high table-lands in distance, standing as a perpetual anomaly in the country.

George Catlin, from Letters and Notes on . . .
the North American Indians *(1844)*

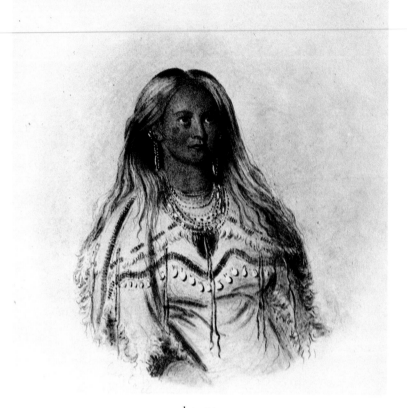

plate 11
George Catlin
Sha-Ko-Ka (Mint, Mandan). *1832. Watercolor on paper,* 5¾ x 4⅞". *0226.1545*

American artists, being loath to venture into the wilderness, had to wait for the wilderness to come to them. It did so initially in the form of Indian delegations, groups that, as a matter of diplomacy, were brought to eastern cities so that they might be influenced toward an acceptance of Anglo expansion. Interested painters had the Indians visit their studios during these trips, thereby being spared the rigors of travel and exposure to the uncertainties of the wilds. Charles Bird King was exemplary of this group of artists.

In 1822 King painted the first of 143 portraits of distinguished Indian visitors to Washington D.C. Commissioned by Thomas L. McKenney, Superintendent of Indian Affairs and later head of the Bureau of Indian Affairs, many of these portraits retain the classical idealization introduced in West's work. This is understandable since West was for several years King's mentor in London.

The portrait of *Terre Kitanahu* (plate 4) or *Petalesharro, the Generous Chief,* is one of six paintings of this subject King is thought to have completed. The Pawnee chief had won his laurels several years before he visited Washington in 1822. Known to his people as the bravest of the brave, he had countered Pawnee tradition by rescuing a young Comanche girl from a sacrificial pyre as she was about to

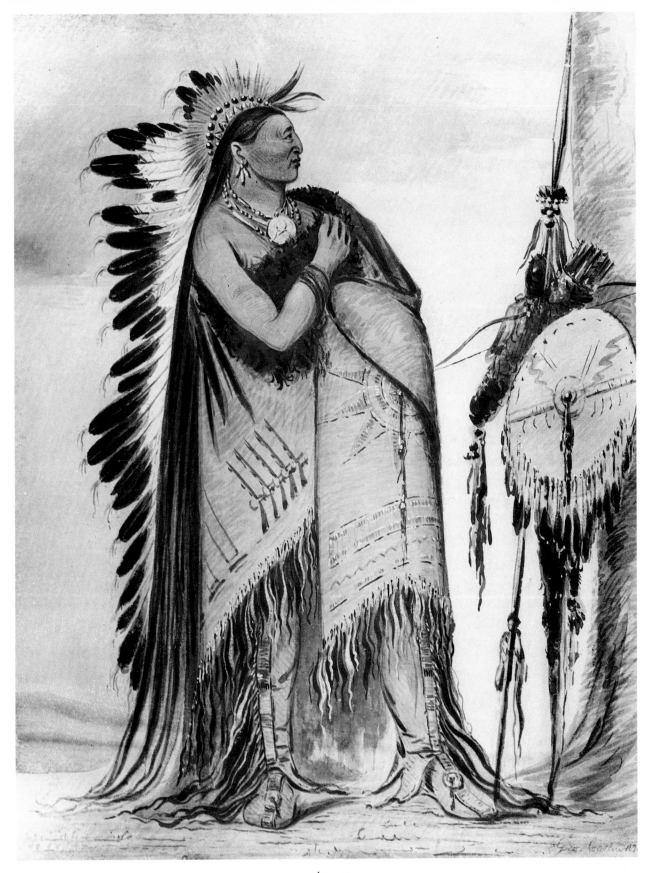

plate 12
George Catlin
Ee-Hee-A-Duck-Chee-A (He Who Ties Hair Before). *1836. Watercolor on paper, 10¾ x 8¼". 0226.1598*

plate 13
Alfred Jacob Miller
Sir William Drummond Stewart
Meeting Indian Chiefs
c. 1837. Oil on canvas, 33 x 42½". 0126.738

The long hair floating about, as raised by the motion of the rider; and the horsetails dangling, and the dust, and the occasional shout; the flashing of the bright gun-barrels in the sun, and the fierce bearing of those who carried them—combined to form a subject alike for the painter and the moralist.

Sir W. D. Stewart, J Watson Webb (editor),
from **Altowan** *(1846)*

plate 14
Alfred Jacob Miller
Fort Laramie *or* Fort William on the Laramie
1851. Oil on canvas, 18 x 27". 0126.727

Tribes of Indians encamp here 3 or 4 times a year, bringing with them peltries to be traded or exchanged for dry-goods, tobacco, vermillion, brass, and diluted alcohol.

Alfred Jacob Miller, from unpublished notes (1859—60)

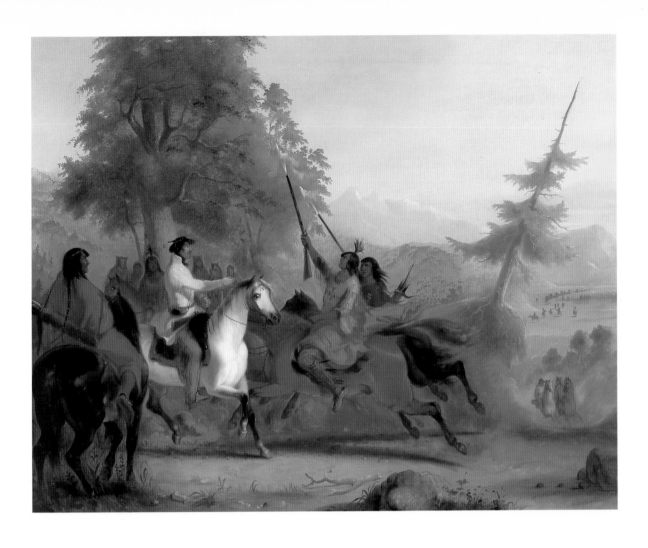

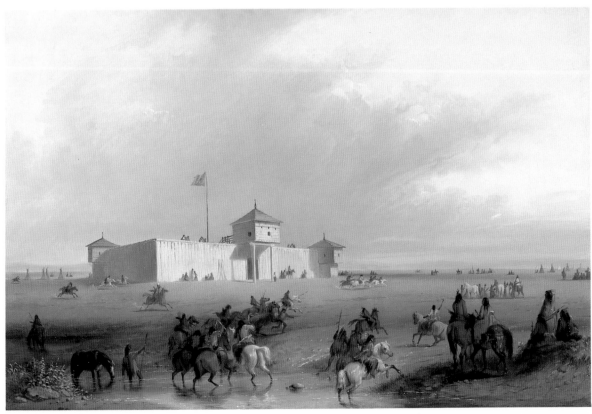

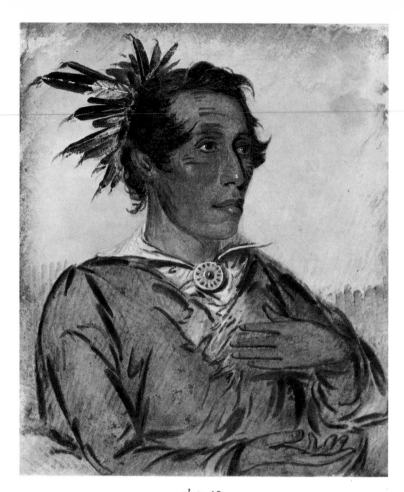

plate 15
George Catlin
Wap-Sha-Ka-Nah (No English, Peoria). *c. 1834. Watercolor on paper,* 5½ x 4¾". *0226.1561*

become a token ember to the morning star. In none of King's portraits of the subject does he indicate reference to the historic event that established the brave's celebrity. Nonetheless, the portraits are remarkable in themselves.

King is known primarily for romanticizing the Indian through his portraits by endowing them with a dimension of monumentality[7] (plates 2 and 3). The artist's rich use of color and technical skill belie the observation of his contemporary William Dunlap, who wrote that it was "industry in painting that has served him instead of genius, in which nature has stinted him."[8]

King's fellow portrait artist John W. Jarvis painted at least one stunning depiction of Indians. His celebrated *Black Hawk and His Son, Whirling Thunder* (plate 5), thought to have been completed in Washington, D.C., during the spring of 1833, is exemplary of Jarvis's more neoclassical approach. A clarity and dignity invest this work, yet it is, after all, simply a portrait. The portrait artists' formulae, rather than the dramatic situation that brought Black Hawk and his son to Washington, are reflected in the glazed stare of the sitters. They had come East to negotiate with President Andrew Jackson for their release as prisoners of war. Jefferson Barracks, the military post at St. Louis, had been their home for the past

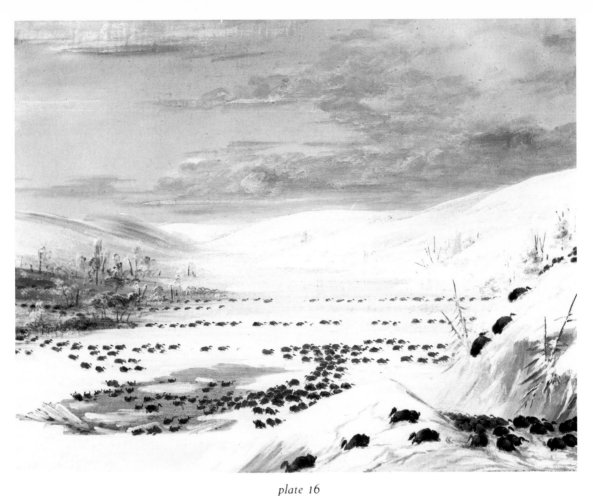

plate 16
George Catlin
Herd of Buffaloes Crossing the Missouri on the Ice. *1852. Oil on canvas, 11⅛ x 14⅝". 0176.2146*

year as a result of their bellicose actions to preserve their Illinois homelands from encroachment.

There is eloquent drama and strong history in Black Hawk's tale. Unfortunately, most American painters were not yet ready for such subjects. It is certain that Jarvis was not. He had painted portraits of both Meriwether Lewis and William Clark, and in neither instance was there a hint of their epoch-making trek. Perhaps portraiture was his exclusive interest, but more likely he had noted that even the great John Trumbull failed to affect native taste for history painting. Subsequent painters of Jarvis's generation, John Vanderlyn and Samuel F. B. Morse, would be forced to survive on portrait painting because of indifference of the American public to scenes from their new nation's history.[9]

The recording of the Western frontier was left to far more pragmatic minds and prosaic talents in these early years of the nineteenth century. Explorer and army engineer Steven H. Long took the first artists west to the Rockies in 1820. Joining his expedition were Philadelphia watercolorist Samuel Seymour, assigned to paint landscapes, and the young naturalist Titian Ramsay Peale, to record the natural elements. They returned with the first definitive, pictorial record of the Far West.

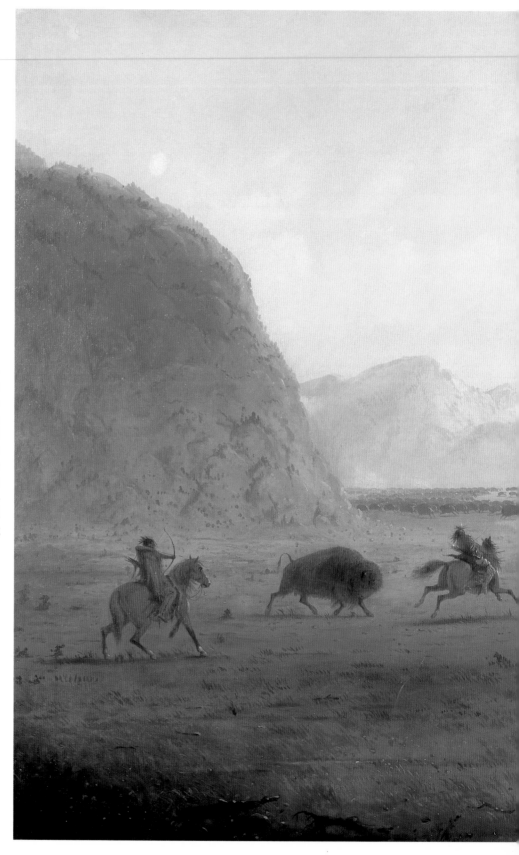

plate 17
Alfred Jacob Miller
Buffalo Hunt
1840. Oil on canvas, 30 x 40". 0126.739

The plain is literally covered with Buffalo, they count by thousands, and are seen as far as the eye can reach;— Hunters . . . must have their wits about them,—fearless, self-possessed, and well mounted on trained horses,—they dash into the midst of the herd in order to select the best animals or those, as they express it, which are "real fat" — . . . others of the party have separated from the main herd and are pursuing this game in all directions.

Alfred Jacob Miller,
from unpublished notes (c. 1840)

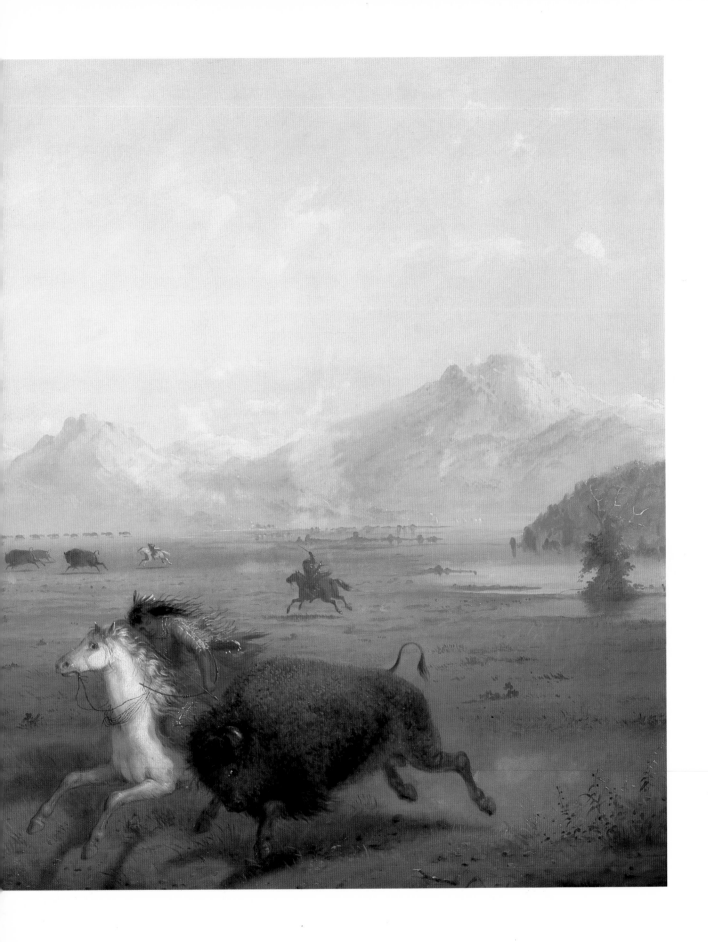

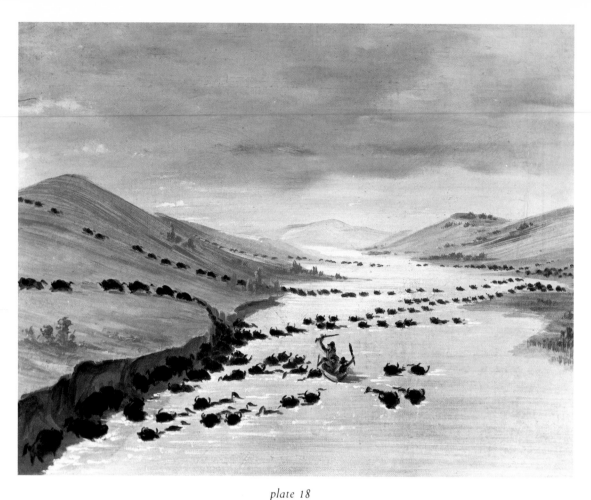

plate 18
George Catlin
Mr. Catlin and His Two Men in a Bark Canoe. *1852. Oil on canvas, 11⅛ x 14¾". 0176.2141*

They were observant, but their images had only moderate impact beyond the intellectual and artistic community. It was a young innocent, one son of an eight-member Swiss immigrant family, who would first bring the West to life through art. Arriving at the ill-fated Selkirk colony on the Red River of Canada in 1821, Peter Rindisbacher brought with him a keen sense of observation and a wonderful talent for pictorial recording.

While Charles Bird King was beginning his noted series of Indian portraits, secure in the comforts of his 12th Street studio in Washington, D.C., during January of 1822, Rindisbacher and his family were pressing to survive their first bitter Canadian winter. During the next several years, while Indian delegates paraded past King's easel, Rindisbacher earned a reputation for preserving the image of life on the frontier. His drawings and watercolors, in jewel-like precision, depicted genre scenes, Indian groups, and historical accounts.

Rindisbacher's best works, completed near his new home, were commissioned by the colony's governor, Captain Andrew Bulger. In the watercolor *Captain Bulger's Palaver* (plate 8) the artist portrays Bulger seated before a delegation of chiefs and warriors. In exchange for this painting and numerous other views, the

plate 19
George Catlin
Eagle Dance *(from sketchbook). c. 1855. Pen and ink on paper, 4 x 6½". 477.6.147*

governor organized a special buffalo hunt so that the young artist might record the excitement of the chase. The artistic results of this and similar experiences eventually won worthy claim beyond Rindisbacher's frontier studio. The Indian chroniclers Thomas McKenney and James Hall described the young Swiss artist as a man of

Uncommon talent, who, lured by his love of the picturesque, wandered far to the West, and spent several years upon our frontier, employing his pencil on subjects connected with the Indian modes of life. His was the fate of genius. His labours were unknown and unrequited. Few who saw the exquisite touches of his pencil knew their merit. They knew them to be graphic, but valued slightly the mimic presentation of familiar realities. They might wonder at the skill which placed on canvas the war dance, or the buffalo hunt, but they could not prize as they deserved, the copies of exciting scenes which they had familiarly witnessed. [10]

Despite the inaccuracy in the authors' conception of what brought Rindisbacher to the West, their assessment of his talent was accurate. His mature watercolors, such as *Introducing the Scalp* (plate 7), evidence the skill with which the

plate 20
Seth Eastman
The Indian Council
1852. Oil on canvas, 26 x 36". 0126.1182

Eastman—thrown for many years among them [the
Indians] by the circumstances of his position in the
Army—has exercised the highest and most culti-
vated art, in giving by brush or pencil such faithful
and elegant representations of the customs, sports,
villages and scenery of their country as are seen in
these volumes. . . . We commend heartily the taste
and foresight shown in inserting these landscapes
of the present Indian country. . . . The perfect truth
of these scenes can only be realized by one who has
seen the originals often.

From Missouri Republican *(1852)*

plate 21
John Mix Stanley
Buffalo Hunt
N.d. Oil on canvas, 40 x 62⅜". 0126.1150

The solid ground shakes as they pass. Clouds of
dust fly from the flying herd. Strong hunters, on
swift horses, draw the feathered arrow to the point;
the sharp lance is driven fiercely. One bold buffalo,
wounded, turns at bay . . . another lies bleeding,
dead. By him stops the Artist, on his steed—to
contemplate his own work, for to-day Stanley has
been a mighty hunter.

John Mix Stanley, from Western Wilds *(1854)*

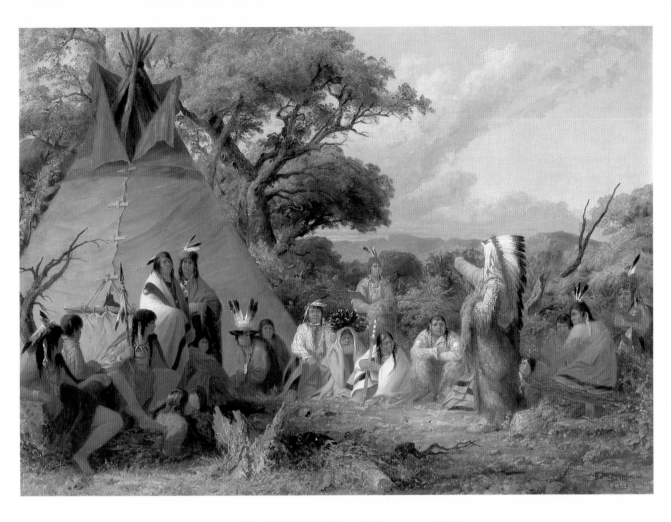

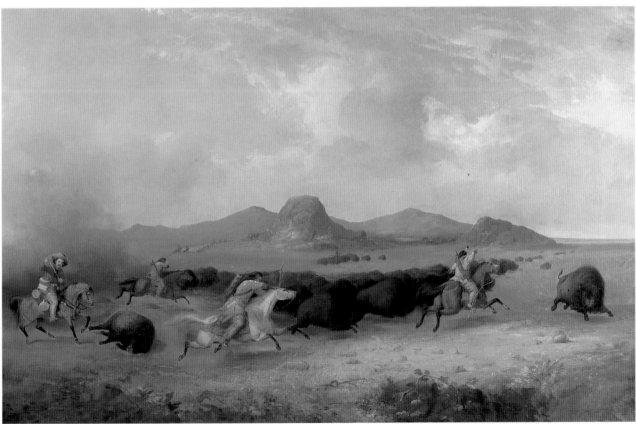

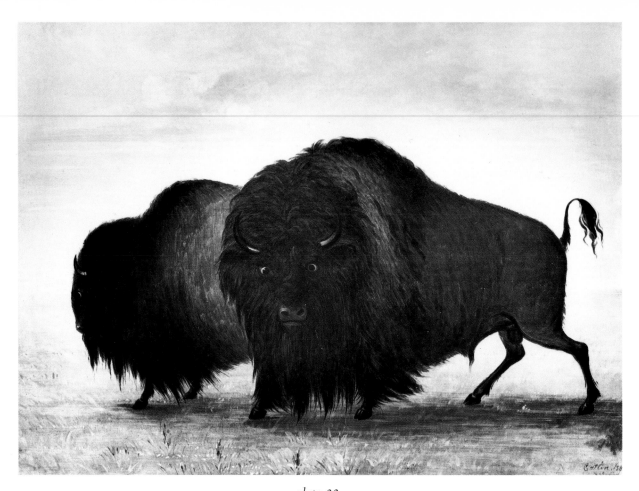

plate 22
George Catlin
Buffaloes. *1854. Oil on canvas, 19 x 26½". 0176.2172*

artist had perfected that medium. In these, the frontier's history unfolded through the precision of a master—one who treated the Indian as "noble savage from an antique mold."[11] The sculptural quality of his anatomical treatment reflected the dictates of classical sculpture. Shortly after Rindisbacher moved to St. Louis in 1829, the *St. Louis Beacon* published a letter that noted this special element: "There is a living and moving effect in the swell and contraction he gives to the muscular appearance of his figures, that evinces much observation, judgement and skill."[12] By the time of Rindisbacher's premature death in 1834, he was listed in St. Louis as a miniature and landscape painter.[13] His views of the prairies and upper reaches of the Mississippi River reflect an empathy for the land as well as the people who inhabited Rindisbacher's frontier.

The Western landscape was beginning to awaken artistic interest even among the ranks of the Eastern establishment group, the Hudson River school, which was coming into ascendancy in the second quarter of the century. Philadelphia artist Thomas Doughty made copies of Samuel Seymour's Rocky Mountain views in the early 1820s.[14] He was later joined in such subjects by his friend and sketching companion Alvan Fisher.

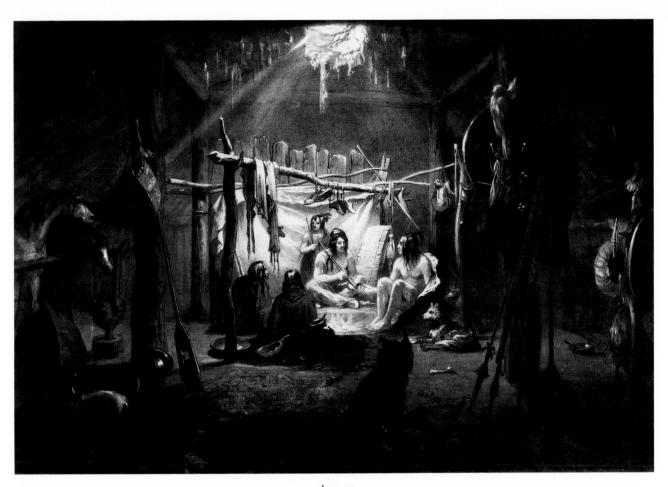

plate 23
Carl Bodmer
Interior of a Hut of a Mandan Chief. *c. 1836. Mixed media on paper, 11 x 16". 0476.7*

Fisher, like Doughty, never visited the West. Yet between 1826 and 1863 he is known to have completed over thirty-five Western views and Indian studies.[15] He was one of the few Hudson River painters to mix anecdotal elements in his landscape, priding himself on introducing genre and historical elements into American art as early as 1815—"a species of pictures which had not been practiced much, if any, in this country."[16] His painting *Pursuit* (plate 6), though no doubt set in New England, evidences this blend of landscape and history with a frontier theme.

In the Far West, what was begun by Rindisbacher in the 1820s was carried on in a much expanded version by George Catlin in the succeeding decade. Driven by a passion for art, a moral commitment to Indian peoples, and a quasi-scientific impulse to record unknown cultures in far corners of the world, Catlin embarked in 1832 on a five-year odyssey through the West. The details of his wanderings provide an extraordinary adventure story in themselves, and the results of his observations, through paintings and written word, were unprecedented in American art and letters.

Catlin was trained as a portrait painter, and in such work he often excelled. His

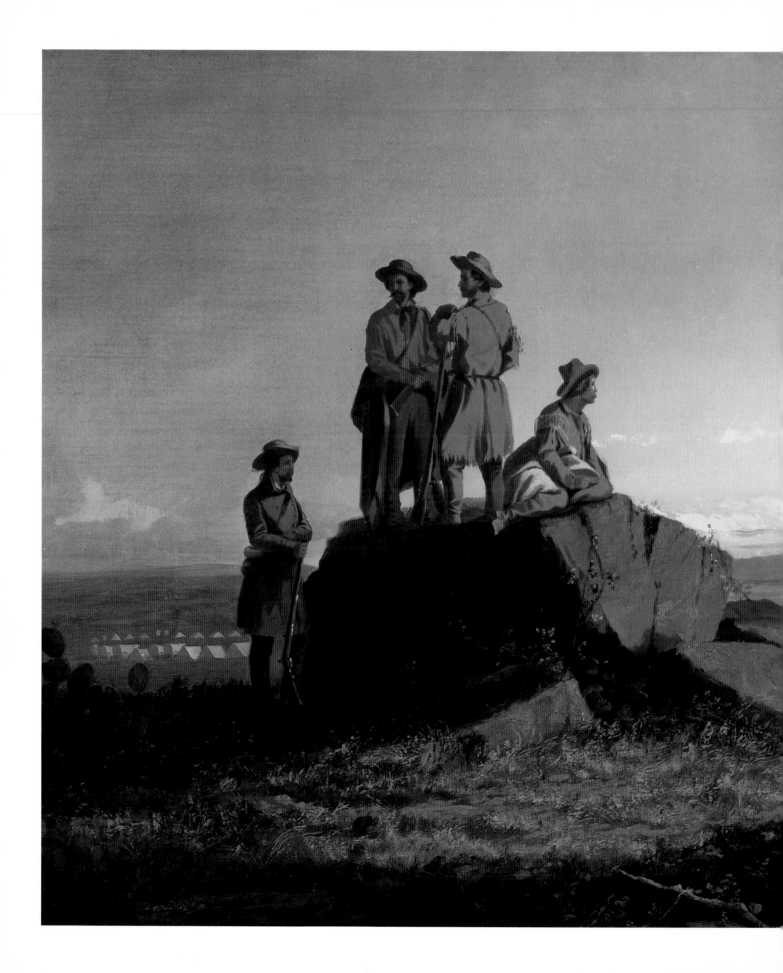

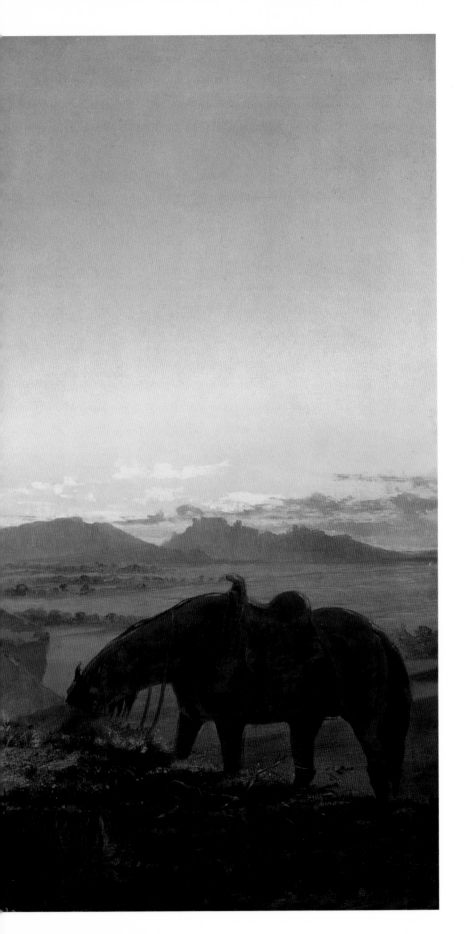

plate 24
John Mix Stanley
Encampment in the Teton Country
1860. Oil on canvas, 24 x 34⅛". 0126.1143

J.M. Stanley, Esq., the artist of the expedition, has taken a great many sketches illustrative of the progress of the [Pacific Railroad Survey] expedition. . . . His reputation, already so well established, cannot be enhanced by any reference to his satisfactory discharge of duty.

Isaac I. Stevens, from a letter to The Oregonian *(1853)*

plate 25
Rudolph Friederich Kurz
Buffalo Dance (Omahas). *1852. Pen/ink/pencil on paper, 13⅝ x 20⅛". 1326.1091*

plate 26
Rudolph Friederich Kurz
Fort Union. *1852. Pen/ink/pencil on paper, 12½ x 15¾". 1326.1093*

affinity for landscape, though not equally acclaimed, should be regarded as one of his major contributions. Fresh color and direct spontaneity imbued such works as *View in the "Grand Detour"* (upper Missouri River) (plate 10) with a sense of delight and awe that the artist confessed to feel while painting the earth's countenance. "I take an indescribable pleasure in roaming through nature's trackless wilds, and selecting models where I am free and unshackled by the killing restraints of society, where a painter must modestly sit and breathe away in agony the edge and soul of his inspiration, waiting for the sluggish calls of the civil," he wrote in 1834. "I am practicing in the true school of the arts."[17]

Catlin's anecdotal persuasions appear in the pictorial accounts of his journey, such as his painting *Mr. Catlin . . . in Bark Canoe* (plate 18). His was a true quest in which the artist became explorer, adventurer, and mythic hero. Such experience separated him at once from most other American artists of his day. As a young man Catlin had clearly stated a desire to become a history painter—in the end, he opted to make history himself and invest his energies in depicting the drama of his own personal exploits. Henry Tuckerman, in recalling the impression made by Catlin's Indian Gallery, the accumulated efforts of six years travel in the West that comprised more than six hundred exhibitable oils by 1848, concluded that "here were trophies as eloquent of adventure as of skill."[18]

Catlin shared the West in the 1830s with a number of equally intrepid artists. Among these was Carl Bodmer, a Swiss painter who traveled up the Missouri River to Fort McKenzie in 1833–34 with Prince Maximilian of Wied-Neuwied. Contrary to Catlin, Bodmer had wished to become a landscape, rather than history, painter. While Catlin was often more interested in the geology than the atmosphere, Bodmer proved a master of detail and light. Reflecting his European background and tastes, Bodmer's views along the Missouri River often concentrated on the crenelated forms reminiscent of ruined castles familiar to travelers along the Rhine River.

The classical restraint of Bodmer's genre scenes differs also from Catlin's more instinctive enthusiasm. Many of Bodmer's finished compositions, designed for engravings used to illustrate Maximilian's writings of the trip, found direct compositional antecedents in known neoclassical works of the day such as Jacques Louis David's *Battle of the Romans and Sabines*. Bodmer's quiet genre scene, an *Interior of a Hut of a Mandan Chief* (plate 23), has less celebrated derivation. The scene was sketched from life among the Mandan villages. The version in the Gilcrease collection is thought to have been the final study for the engraved illustration which embellished the published journals.

In 1839, several years after Bodmer had returned to Europe, he had occasion to advise a young fellow Swiss artist, Rudolph Friederich Kurz, on preparations for painting in the Far West. "He wisely urged me not to be in too great haste," Kurz wrote in his diary, "but first to become so practiced in the drawing of natural objects . . . that the matter of technique would no longer offer the least difficulty."[19] After proper training, Kurz did come to America on a professional art tour of the upper Missouri River. Although personally influenced by Alexander von Humboldt, he was not scientifically motivated, and unlike Catlin his purpose was not

Mr. Deas seemed to possess the whole secret of winning the good graces of the Indians. Whenever he entered a lodge it was with a grand flourish and a mock bow that would put even an Ottoman in ecstasies. And as he said he was sure they did not understand English, he always gave his salutations in French and with a tone and gestures so irresistibly comic that, generally, the whole lodge would burst out into a roar of laughter, though not a shadow of a smile could be seen on his face.

From the journal of Lieutenant J. Henry Carleton (1844)

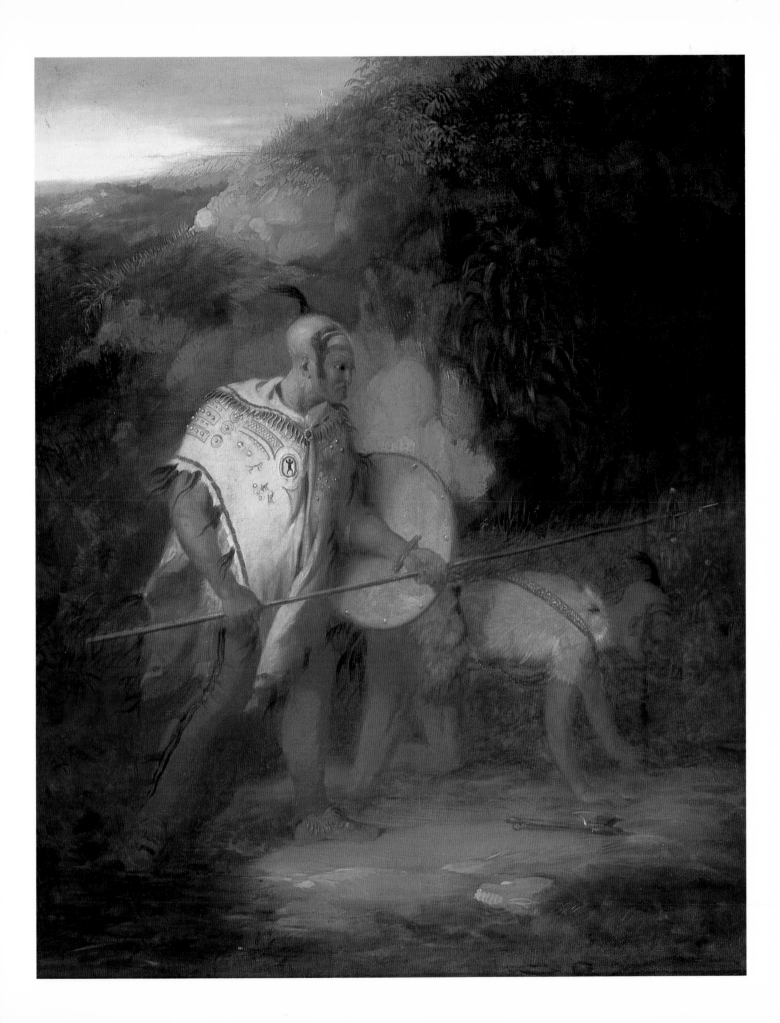

A Snake Indian giving a
description of a party who
have previously passed — by
trails left on the ground.

plate 28
Alfred Jacob Miller
The Indian Oracle *or* **A Snake Indian Giving a Description** . . . *N.d. Mixed media on paper, 11 x 8⅞". 0236.1072*

"to portray the Indian as an end in itself but to employ that type as a living model in the portrayal of the antique."[20]

Kurz's drawing of the *Buffalo Dance* (plate 25) presents the artist, first of all, as a natural observer. The precise elegance of his drawing reveals lessons he had learned from the study of engravings after the antique. Yet compared compositionally with Bodmer's work of a similar theme, *Dance of the Mandan Buffalo Society*, which has distinct neoclassical derivations, Kurz's portrayal is surprisingly naturalistic. He had found among the Indians of the upper Missouri his artistic ideal, "the perfect human form" in Adamic innocence. Here was satisfied his "loftiest conception of beauty [which] is man in his first perfection."[21]

In Kurz's interior view of *Fort Union* (plate 26) he extends the linear precision of his statement to genre elements much as Rindisbacher had done thirty years earlier.

The dramatic chiaroscuro and exotic setting of Bodmer's earlier Mandan scene attest to the artist's romantic perceptions. He was succeeded in the West by an American artist who expanded that romantic vision even further. This was Alfred Jacob Miller, a painter born in Baltimore, trained in Philadelphia, and elevated by benefit of a Grand Tour through Europe's cultural centers. Miller's primary dedication was to portraiture, from which he made his living. Copies he made in Europe from portraits by Sir Joshua Reynolds and Sir Peter Lely were forerunners to his success with that form. Nonetheless, he was stirred by the work of his contemporaries Eugene Delacroix and J. M. W. Turner. Visits to artists' studios, especially that of the history painter Horace Vernet, then working in Rome, provided the highlights of his trip.

The opportunity to see and paint the West came for Miller in 1837, a few years after he returned to America. At the invitation of Captain William Drummond Stewart, Miller was signed on as official artist for a holiday to the Rockies. The purpose of the trip reflected no scientific intentions but rather the pictorial recording of a romantic adventure to a remote corner of the world. Miller was challenged to combine the landscape and narrative forms. This he did with a suffused elegance and romantic vitality that brought him a unique place in the art of the West.

The first and most important subject for Miller's brush, of course, was his patron Stewart, hence most of the works resulting directly from the expedition include the Scotsman. In the oil painting *Sir William Drummond Stewart Meeting Indian Chiefs* (plate 13), the scene was adjusted to fit the patron's taste. The original watercolor sketch for this painting shows Stewart within the same composition, greeting trappers rather than Indians at the rendezvous. The later oil version, painted for the walls of Stewart's ancestral home, Murthly Castle, was changed according to the sitter's disposition. The anecdotal element is essentially unaltered but the historicity is considerably affected.

Miller's interpretation of the human element in the West centered on the embryonic interphasing of civilization and wilderness. He viewed the free trapper as the symbolic middleman in this reconciliation.[22] His watercolor of *The Indian Oracle* (plate 28) pictures the hospitable interaction that Miller considered typi-

plate 29
William Tylee Ranney
Daniel Boone's First View of the Kentucky Valley
1849. Oil on canvas, 36 x 53½". 0126.1233

No populous city, with all the varieties of commerce and stately structures, could afford so much pleasure to my mind, as the beauties of nature I found here. . . .

John Filson, from The Discovery, Settlement and present State of Kentucky

plate 30
Arthur F. Tait
The Check
1854. Oil on canvas, 30 x 44".
Gift of Bailie Vinson. 0126.1159

We readily guessed that these Indians were in arms to revenge the death of those which our men had killed up the river; and if they could succeed in getting any advantage over us, we had no expectation that they would give us any quarter.

Zenas Leonard, from Narrative *(1839)*

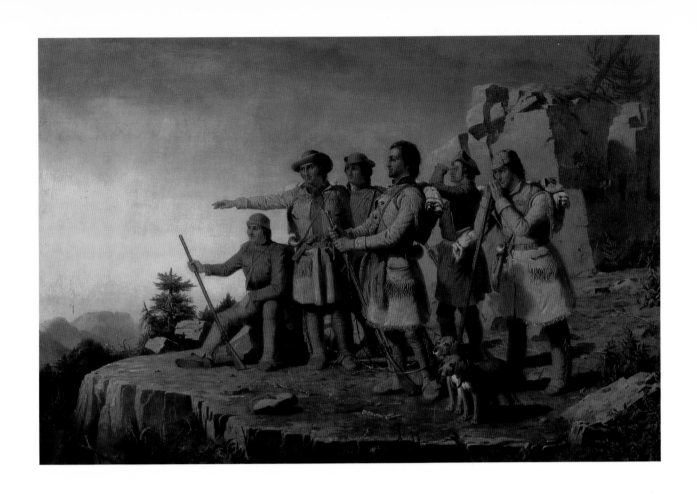

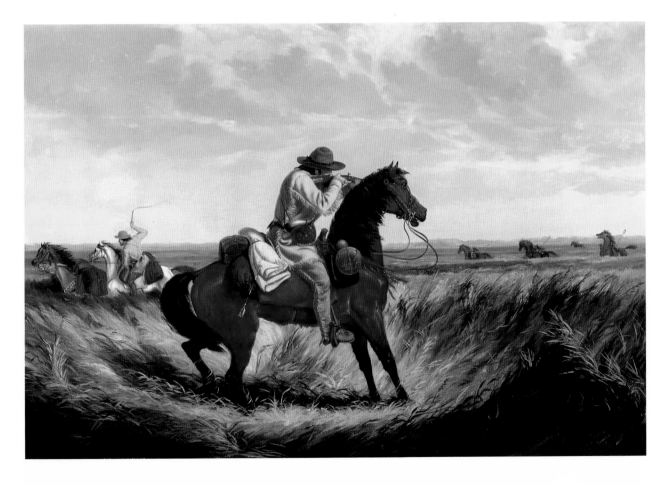

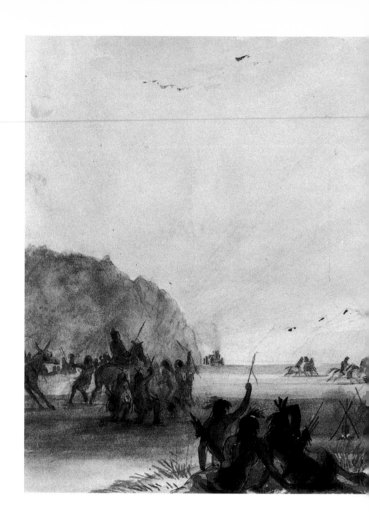

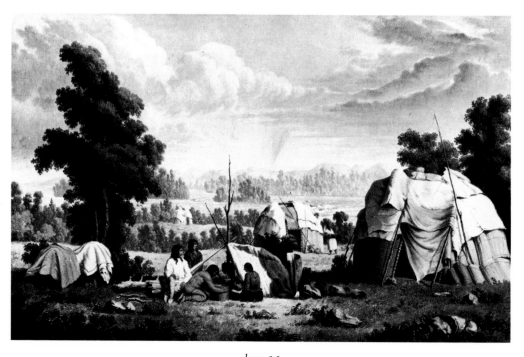

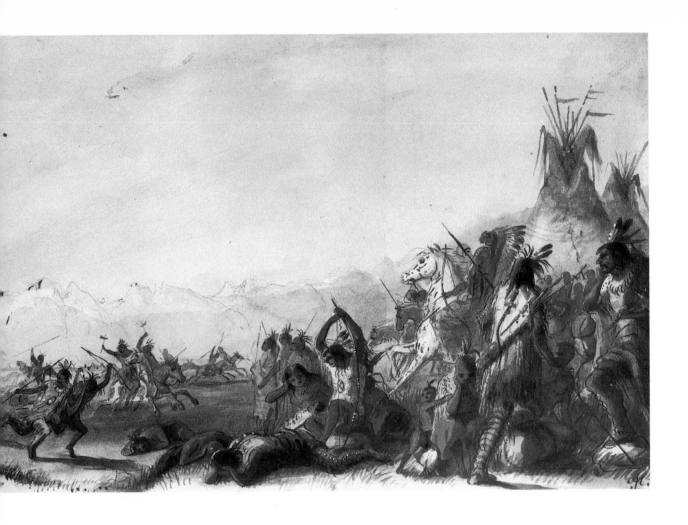

cal. Similar anecdotal themes depicting trappers with Indian brides proved popular images for Miller's patrons in Baltimore.

Miller is known today for preserving many elements of Western history that survive otherwise only in literature. The mountain man was testament to the spirit of free will and entrepreneurial zeal that launched the nation into an era of expansion. Nothing was more at the heart of that enterprise than Fort Laramie, which found its way into dozens of Miller's works (plate 14). Built for the American Fur Company, this celebrated edifice intruded on the wilderness some eight hundred miles west of St. Louis. Miller was the only artist known to have recorded it. He was also not beyond creating as well as preserving history. His watercolor *Advent of the Locomotive in Oregon* (plate 31), probably painted late in the artist's career, captures for the imagination events that were yet to unfold. The Indians react with divergent attitudes, from resignation to panic. It was symbolic of the fact that the wilderness life was passing, a subject about which Catlin wrote extensively and one that would find frequent pictorial expression during the mid-nineteenth century.

Sharing a place with Miller and Catlin as purveyors of sentiment over the impending demise of the Indian was a brilliant soldier-artist named Seth Eastman.

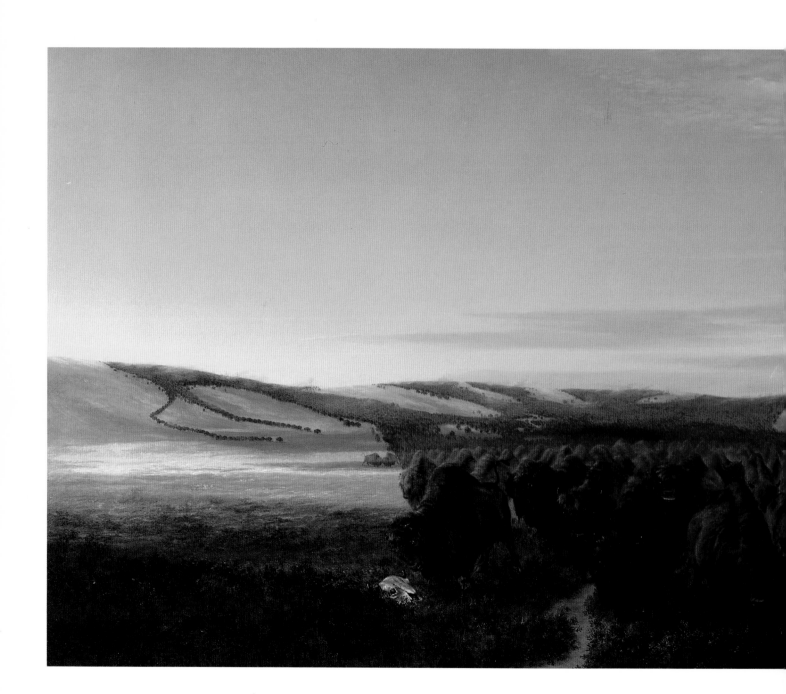

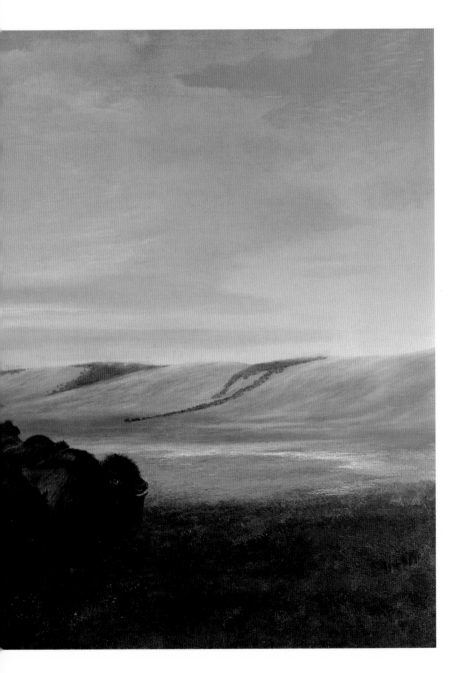

plate 33
William Jacob Hays
A Herd of Buffaloes
on the Bed of the River Missouri
c. 1860. Oil on canvas, 36 x 72". 0137.533

At some seasons (and particularly in the fall) these prairies are literally strewed with herds of this animal. Then, thousands and tens of thousands might at times be seen. . . .

Josiah Gregg,
from The Commerce of the Prairies *(1844)*

plate 34
Seth Eastman
Minne-Ha Ha Falls *or* **The Laughing Waters.** *Before 1845. Oil on artistboard, 18 x 13⅞". 0126.1121*

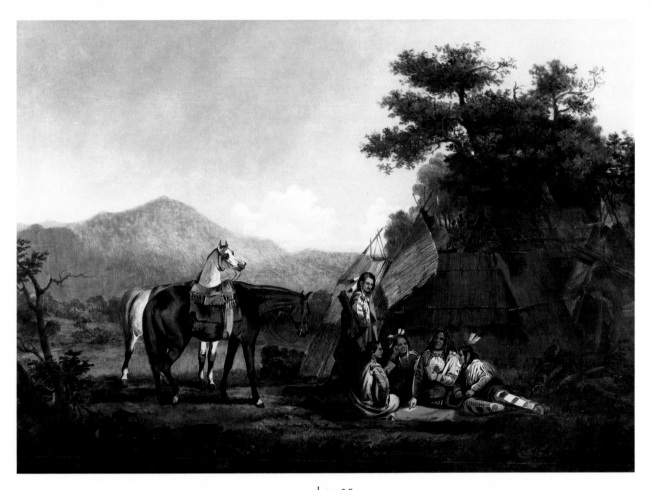

plate 35
John Mix Stanley
Game of Chance. c. 1853. Oil on canvas, 28¼ x 39⅜″. 0126.1137

Eastman arrived on the frontier in 1830. Through the remainder of his career he utilized images of Indian and frontier life as the hallmarks of his work.

Eastman spent years as an instructor of painting at West Point, where he gleaned a fundamental sympathy for wilderness landscape as portrayed by the Hudson River artists of his day. The combination of Rousseauean ideal and regard for the inherent beauty of American scenery was eloquently expressed in the artist's view of *Minne-Ha Ha Falls* (plate 34). Here the Indian, silhouetted before the impressive cascades at the headwaters of the nation's broadest river, represented the unique synthesis of man and nature found only in the American wilds.

The theme of the Indian orator as emblem of the noble savage pervaded much mid-nineteenth-century literature and art.[23] Eastman employed this theme with notable success in his painting *The Indian Council* (plate 20). Restrained and quietly objective compared to similar works by contemporaries, this painting is richly colored and eloquently presented. It is a tribute to Eastman's artistic skill, explaining why at least one Western observer would rank him "as out of sight the best painter of Indian life the country has produced."[24]

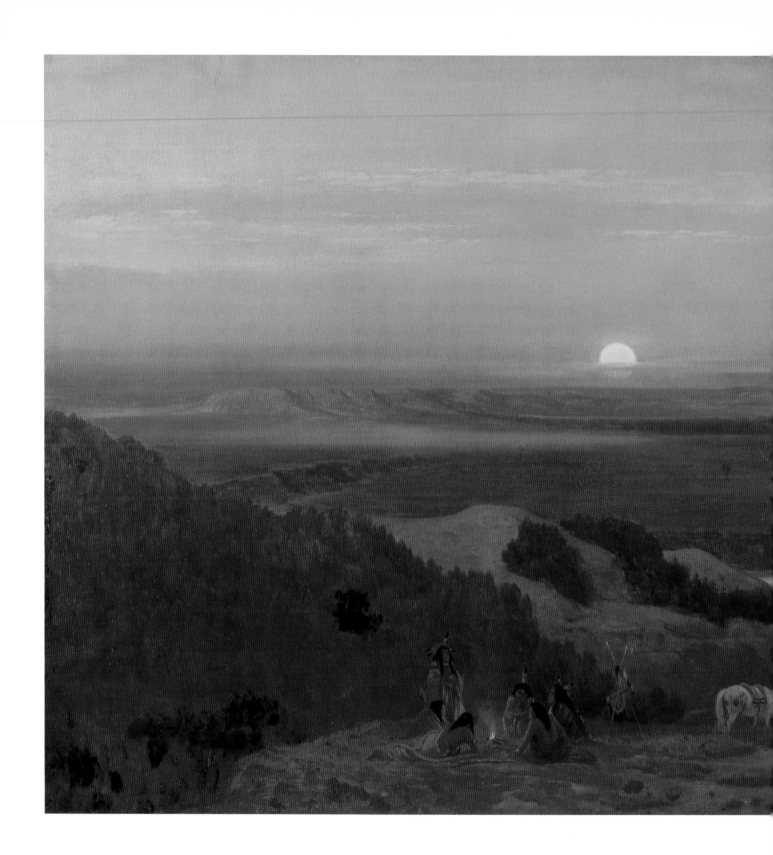

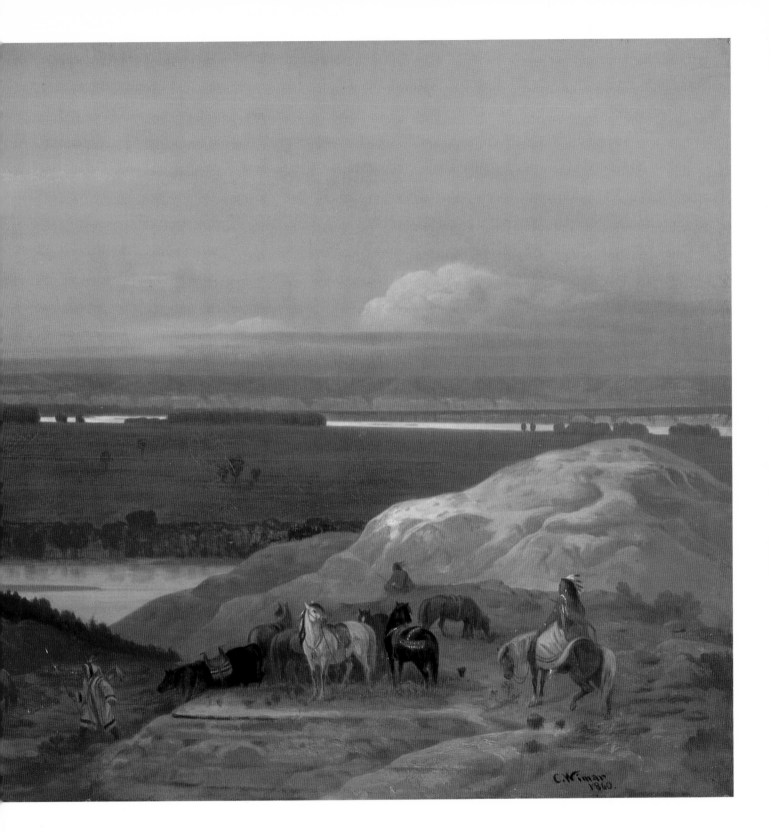

plate 36
Carl Wimar
Indian Encampment on the Big
Bend of the Missouri River
1860. Oil on canvas, 25 x 49". 0126.1598

Whenever I crossed this magnificent river the sensations which I experienced bordered on the sublime, and my imagination transported me through the world of prairies which it fertilizes, to the colossal mountains whence it issues.

From a letter by Father de Smet (1841)

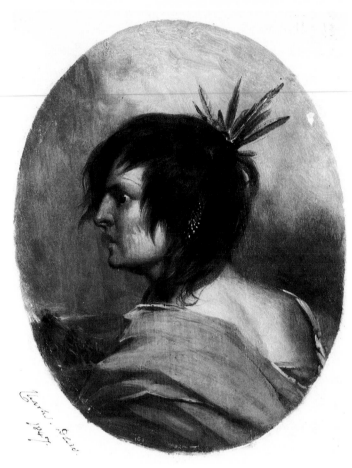

plate 37
Charles Deas
River Man—Indian Brave. *1847. Oil on board, 10 x 14". 0126.1151*

In 1849 Eastman was invited by the Office of Indian Affairs to illustrate the definitive treatise of Henry R. Schoolcraft on the *Indian Tribes of the United States.* Such paintings as *The Indian Council* later embellished that distinguished work. His career was made, and other artists would soon be looking to him for acknowledgment. Among those was John Mix Stanley, who represented a second generation of artists dedicated to exploring and exploiting Western imagery. Stanley's special focus was on the Indian, and he competed directly with Catlin to establish a recognized Indian Gallery representative of the native American tribes that they predicted would soon find extinction under the press of Anglo civilization.

Stanley's painting of a *Game of Chance* (plate 35) illustrates his interest in the everyday life of the Plains Indians. The balanced composition, resplendent with the richly colored costumes of the Blackfoot Indians, speaks subtly of the introduction of Anglo customs that Stanley devotedly bemoaned. In this quiet genre scene the Indians gamble with a standard deck of European playing cards.

Stanley was equally enamored of the land and of the drama that unfolded on the

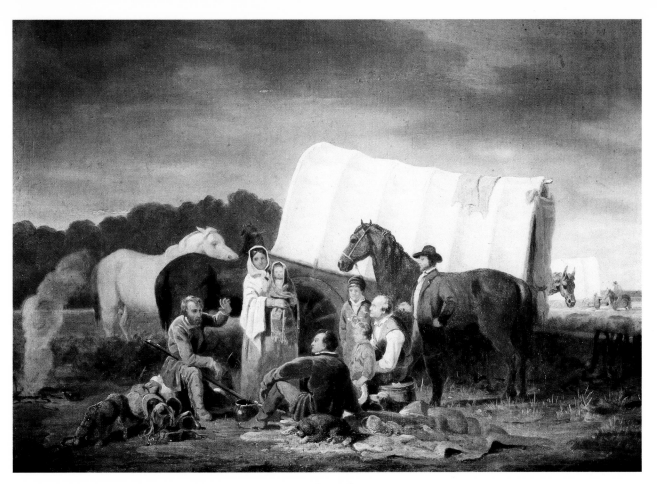

plate 38
William Tylee Ranney
The Old Scout's Tale. *c. 1853. Oil on canvas, 13 ½ x 19 ½". 0126.2261*

broad western plains, and this is demonstrated in his two paintings *Buffalo Hunt* (plate 21) and *Encampment in the Teton Country* (plate 24). Both works were inspired by scenes observed while Stanley was official artist on the transcontinental railroad survey along the forty-ninth parallel. The former painting shows the artist joining in on a Piegan buffalo hunt much in the tradition of Captain Stewart or Catlin in his quest for adventure. The latter, a scene along the expedition's route, portrays members of the Isaac Stevens party at the foot of the Rockies gazing toward the setting sun and pondering the promise of national expansion with a transportation link to the Pacific Ocean.

While Stanley was perhaps more curious about the anecdotal elements of Indian and frontier life than his predecessors, except Miller, it was a little-known St. Louis artist, Charles Deas, who first capitalized fully on the narrative element within the Western milieu. Praised for the "marked national character"[25] of his work, Deas explored themes of contest and compatibility between the trapper and the Indian. He traveled widely among the Indians during the mid-1840s, returning with the fundamental conviction that survival in nature was still a matter of de-

Westward the Course of Empire Takes Its Way
c. 1862. Oil on canvas, 30 x 40". 0126.1615

To represent as near and truthfully as the artist was
able the grand peaceful conquest of the great west.
. . . Without a wish to date or localize, or to repre-
sent a particular event, it is intended to give in a
condensed form a picture of western emigration,
the conquest of the Pacific slope. . . .

Emanuel Leutze, from unpublished notes (1861)

In the Sierra Nevada Mountains *or* Yosemite Valley
from Inspiration Point
c. 1863. Oil on canvas, 18 x 24". 0126.1180

That name [Inspiration Point] had appeared pedan-
tic, but we found it only the spontaneous expres-
sion of our feelings on the spot. We did not so much
seem to be seeing from that crag of vision a new
scene on the old familiar globe as a new heaven and
a new earth into which the creative spirit had just
been breathed.

Fitz Hugh Ludlow, from Atlantic Monthly *(1864)*

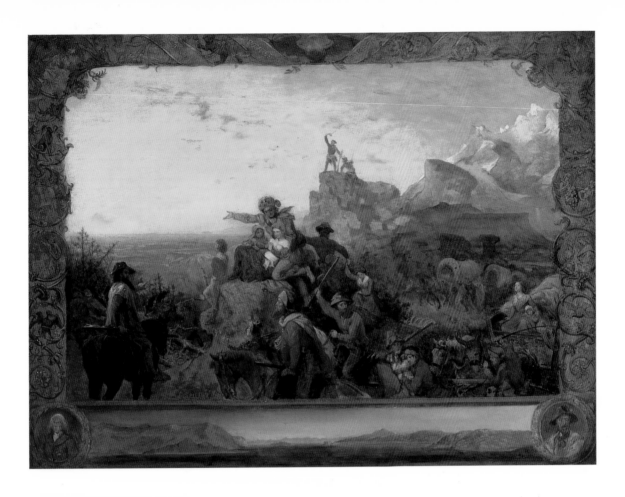

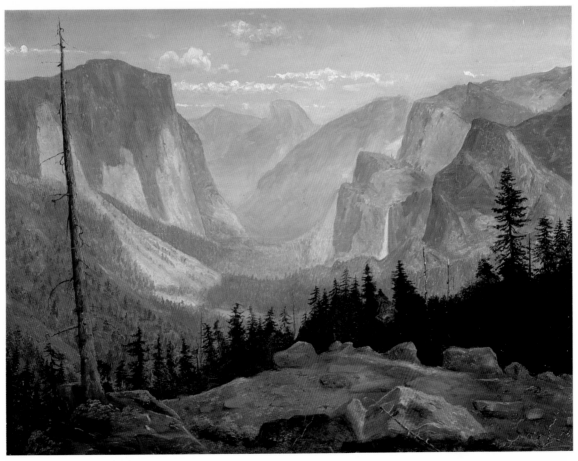

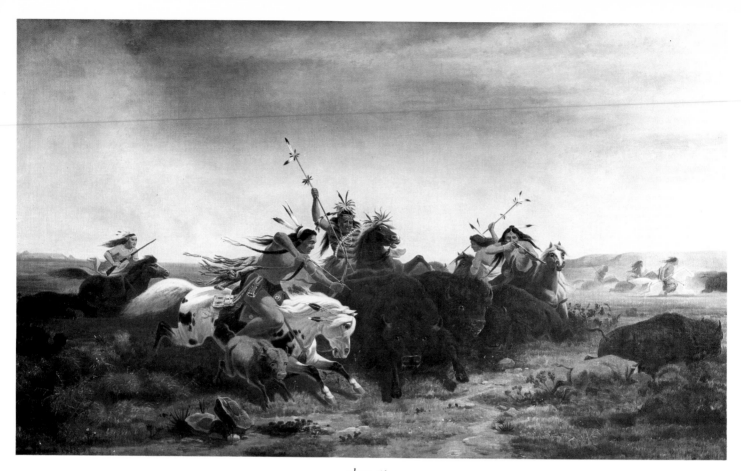

termined personal resolution. This is seen in his matched portraits of *River Man—Indian Brave* (plate 37), who face each other as counterposing players in a predestined adversarial scenario.

Henry Tuckerman, this nation's most preeminent nineteenth-century observer of American art, proposed that Deas's inspiration had derived from Catlin's Indian Gallery and the native "people, about whose history, romance and traditions alike throw their spells!"[26] Deas traveled in 1844 among the Pawnee villages where he won, by stint of personal character and adaptive genius, the Indian name for "Rocky Mountains." More important than the name, he was provided a firsthand picture of Indian life. The stealth of his *Pawnees on the Trail of an Enemy* (plate 27) elaborates on a theme that Deas perceived as crucial—the contest of human survival in the wilderness. The Indians are defenders of a coveted domain, and the artist confirms their resolve.

By the mid-nineteenth century, American painters began to explore historical Western themes in their work. George Caleb Bingham, living in St. Louis, concentrated during these years on the life sustained by the mighty Mississippi that flowed before him. Though most of his paintings were genre statements in rich

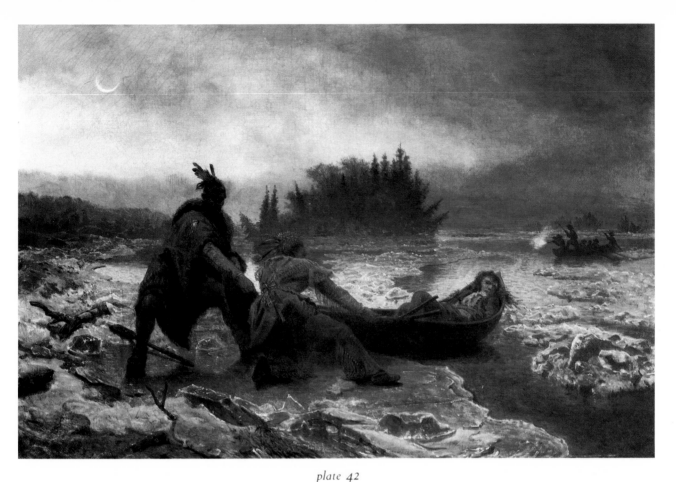

plate 42
Emanuel Leutze
Indians Hauling Rowboat with Bound Captive. *c. 1855. Oil on canvas, 16 x 24½". 0126.1614*

neoclassical form, a few memorialized significant historical events, such as Daniel Boone's renowned trek through the Cumberland Gap.[27]

Other important artists of the period followed such literary leads as Timothy Flint's *Biographical Memoir of Daniel Boone,* published in 1833, and gloried in the unfettered heroics of this homespun national figure who had guided the democratic ideal ever westward. William Ranney, an artist from Hoboken, New Jersey, preceded Bingham in the rendering of such subjects. According to Henry Tuckerman, Ranney "had caught the spirit of border adventure, and was enamored of the picturesque in scenery and character outside of the range of civilization; and to represent and give them historical interest was his artistic ambition."[28] In Ranney's painting of *Daniel Boone's First View of the Kentucky Valley* (plate 29) the statuesque figures, exuding the optimistic promise of American expansion, scan the western horizon. The prominent figure in this scene (and in the Ranney painting as well) is recorded as eulogizing that "this wilderness blossoms as the rose; and these desolate places are as the garden of God."[29]

Ranney's inspiration traveled westward with the gaze of Boone and his companions. His painting of *The Old Scout's Tale* (plate 38), completed several years later,

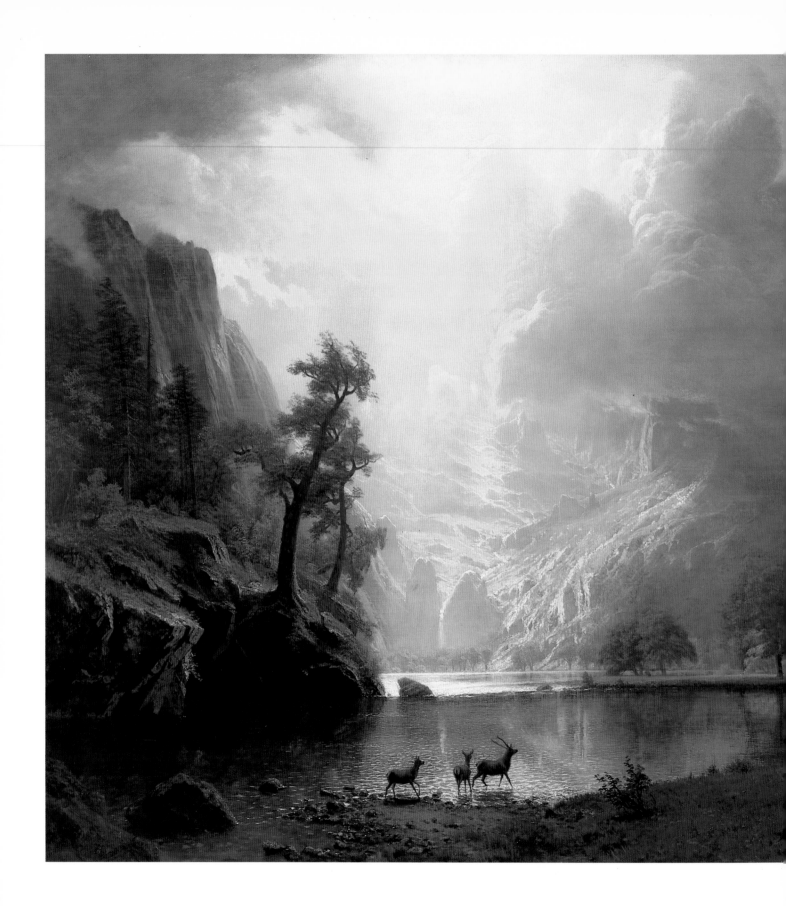

We welcome a man like Bierstadt, who, though as devoted a lover of the grandest scenes in nature as any painter who ever lived, is, at the same time, given to plotting and planning for purely artistic ends. He is always trying for luminous gradations and useful oppositions, and reaches what he tries for.

Henry T. Tuckerman,
from Book of the Artists *(1867)*

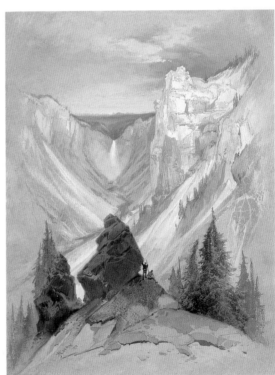

I place no value upon literal transcripts from Nature. My general scope is not realistic, all my tendencies are toward idealization. . . . Topography in art is valueless . . . while I desired to tell truly of Nature, I did not wish to realize the scene [Grand Canyon of the Yellowstone] literally, but to preserve and to convey its true impression.

Thomas Moran, from a letter to G.W. Sheldon (1881)

is thought to portray Jim Bridger, whom many people considered the "Daniel Boone of the Rocky Mountains."[30] The pioneers and their Conestoga wagons became frequently employed subjects for the artist. As in most of Ranney's work, the scene establishes a sense of quiet charm and optimism within a frontier setting.

Ranney's contemporary Arthur F. Tait was of a different persuasion. Although a proponent of the narrative form like Ranney, Tait seemed more inclined toward the drama of frontier life than its simpler moments. Tait, like Charles Deas, romanticized the contest between Indian and trapper. The struggle for survival became the central theme of that artist's well-known series documenting life on the prairies. Paintings such as *The Check* (plate 30) recorded events that Tait never experienced, and a prairie upon which he never set foot. They became, nonetheless, America's most consumable images of the Far West. As reproduced in lithographic form, such pictures were disseminated by Currier and Ives.

Regarded in his day primarily as an animal painter, Tait excelled in the depiction of horses in action, especially at the height of a buffalo hunt. As for the buffalo themselves, William J. Hays of New York was their most significant portrayer

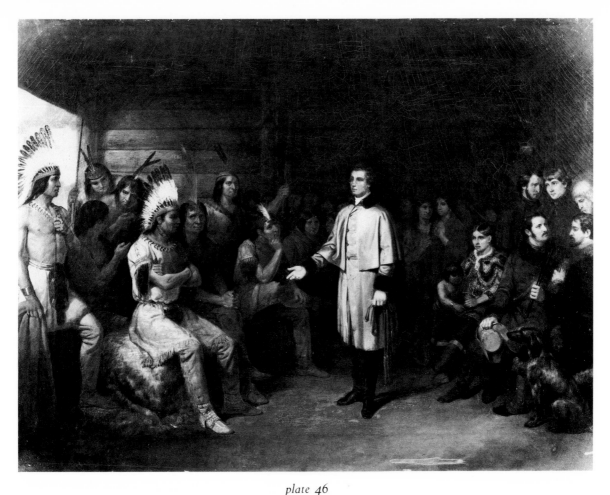

plate 46
Junius Brutus Stearns
Washington in Conference with Representatives of Six Nations. *c. 1855. Oil on canvas, 38 x 50". 01—.1514*

during the mid-nineteenth century. Following a summer trip up the Missouri River in 1860, Hays produced the most seminal buffalo picture of his time, *A Herd of Buffaloes on the Bed of the River Missouri* (plate 33). At its display the next year in New York City, the accompanying gallery brochure assured that this was a credible assessment rather than a romantic overstatement. "By the casual observer this picture would, with hardly a second thought, be deemed an exaggeration, but those who have visited our prairies of the far West can vouch for its truthfulness."[31] As if pushed by the flood of their migratory instincts, the animals seem to flow over the vast terrain. Hays's composition succeeds in conveying the imposing animate force as it envelops the rolling plain.

The compelling sweep of landscape along the upper Missouri also inspired a contemporary of Hays's, Carl Wimar. Raised in St. Louis and educated in Düsseldorf, Germany, Wimar combined a love of the West with firm control of the technical skills necessary to record its life. While studying in Germany, Wimar had produced a number of romantically stylized genre pieces depicting elements of frontier adventure. When he returned to St. Louis in the late 1850s, he was determined to travel west to gain a firsthand exposure. Several trips up the Missouri

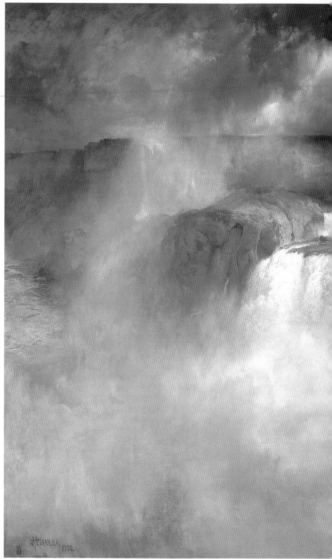

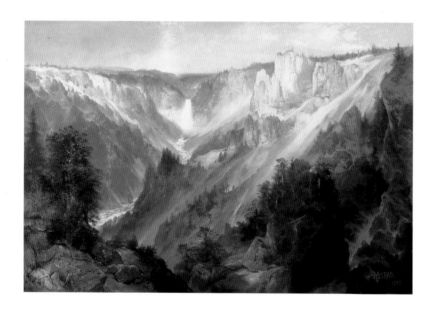

plate *47*
Thomas Moran
Lower Falls, Yellowstone Park
(Grand Canyon of the Yellowstone)
1893. Oil on canvas, 40½ x 60¼". 0126.2344

It is as glorious in color as ever and I was com-
pletely carried away by its magnificence. I think I
can paint a better picture of it than the old one after
I have made my sketches.

Thomas Moran, from a letter to Molly Moran (1892)

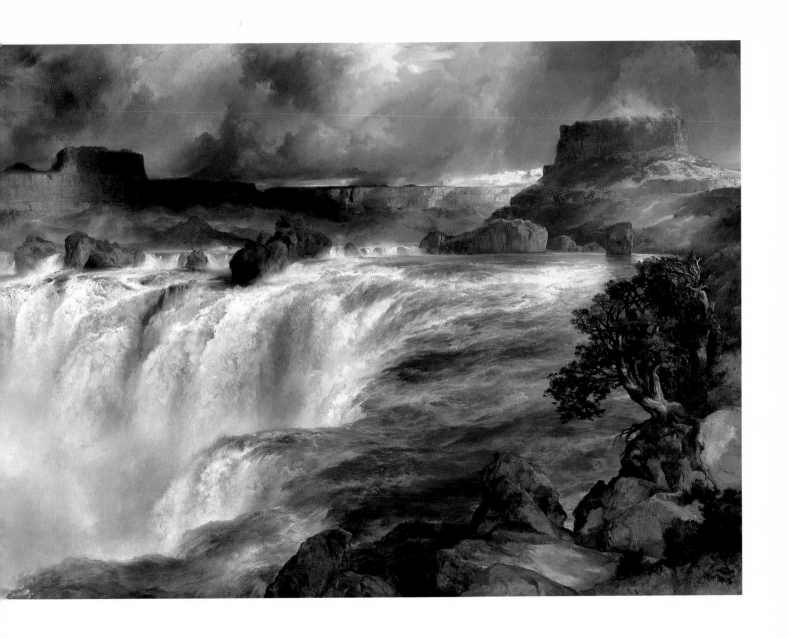

plate 48
Thomas Moran
Shoshone Falls on the Snake River
1900. Oil on canvas, 71 x 132". 0126.2339

The canvas is very large, but the painter has not re-
lied upon size to suggest bigness, having resolutely
attacked the big elements of his subject—the rock
formation, like giant ramparts and bastions, and
the plunge of the mass of water.

Charles A. Caffin, from Harper's Weekly *(1901)*

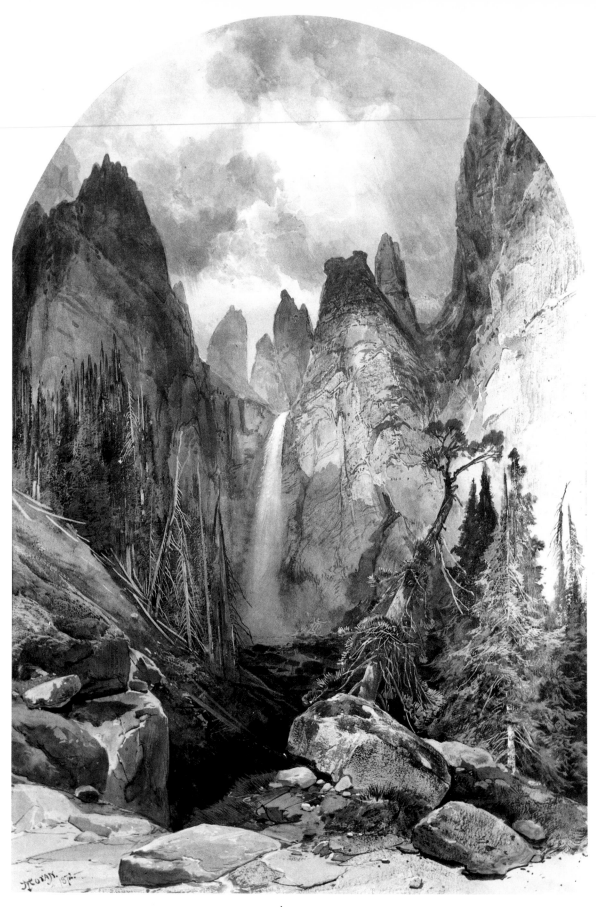

plate 49
Thomas Moran
Tower Falls. *1872. Watercolor on paper, 11¼ x 7¾″. 0236.1457*

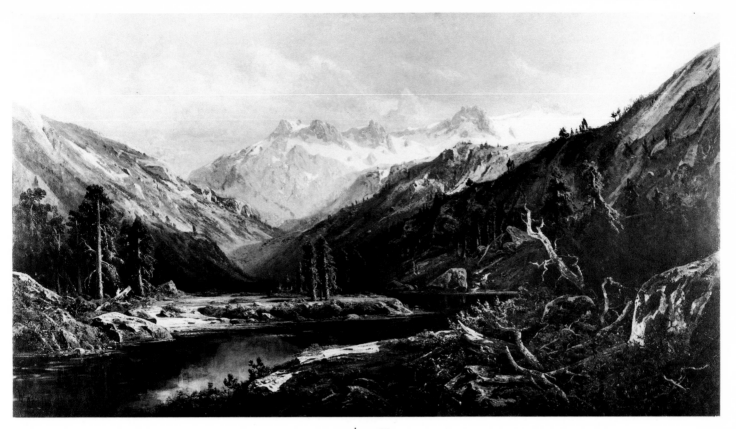

plate 50
William Keith
Sierra Nevada Mountains. *1876. Oil on canvas,* 40⅝ x 72⅝″. 0116.2077

River prior to 1860 served this purpose, enabling him to picture Western light and life with singular beauty. His *Indian Encampment on the Big Bend of the Missouri River* (plate 36), painted that year, proved the young artist an astute observer and exquisite colorist.

In the same year Wimar also completed one of several versions of *The Buffalo Hunt* (plate 41). Rich with the same palette as his *Indian Encampment,* this work represents the Düsseldorf influence in its stop-action *tableau* style. The dramatic circular flow of action focusing on the center of the composition became a hallmark of Wimar's work—a convention, along with the meticulous surface finish, drawn directly from his German influences.

The Düsseldorf Academy of Art aspired to perpetuate through its artists the grand in nature and the heroics of history that might be used to symbolize nationalistic character. Wimar's teacher during his later years at the academy was an American, Emanuel Leutze, who raised these standards to their fullest expression within the narrative tradition (plate 42). In 1859, the same year his pupil Wimar was completing the first major works resulting from his trip up the Missouri River, Leutze returned to America to proceed with a commission from the

The horse herds were moved in from the llano and rounded up in the corral, from which the punchers selected their mounts by roping, and as the sun was westering they disappeared, in obedience to orders, to all points of the compass. The men took positions back in the hills and far out on the plain; there, building a little fire, they cook their beef, and, enveloped in their serapes, spend the night. At early dawn they converge on the ranch, driving before them such stock as they may.

Frederic Remington, from Pony Tracks *(1895)*

Farny paints not only the real Indian and his real life, but he paints the real scenery of the real Indian country, from the brilliantly coloured mesas of the Zuni territory to the wild, drear, snow-tipped canyons of the Yellowstone and Buttes of the Bad Lands of the Sioux.

From The Cincinnati Commercial Gazette *(1893)*

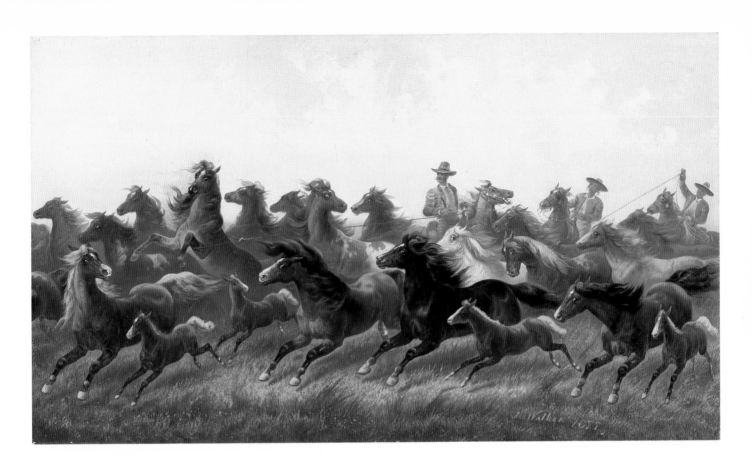

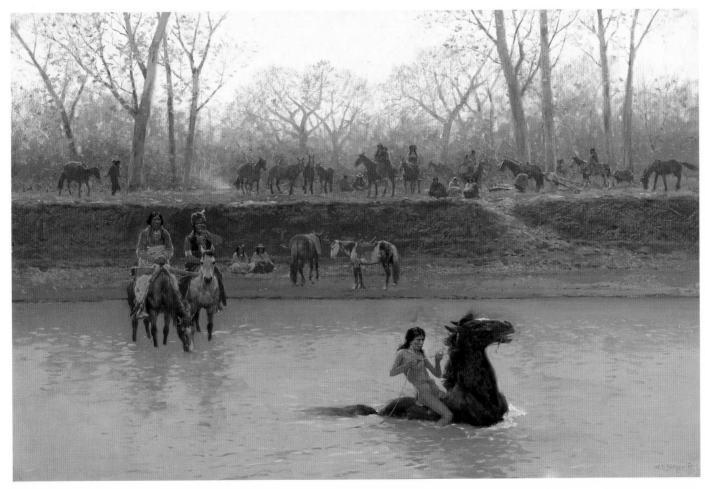

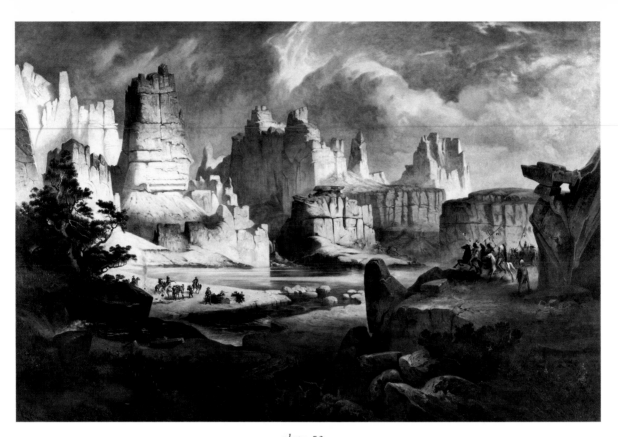

plate 53
Rudolf Cronau
The Green River in Utah. *1885. Oil on canvas, 54 x 79½". 0126.1187*

United States government—the production of a mural for the Capitol's House of Representatives, *Westward the Course of Empire Takes Its Way.*

Like Wimar, Leutze wanted direct exposure to the West to play a part in the empirical process of conceiving such an important work. Traveling to Denver and the goldfields beyond in 1861, he proposed, according to the *Rocky Mountain News,* to secure "sketches, designed to form a prominent feature in his forthcoming painting."[32] These completed, he returned to his studio to produce finished studies for presentation to those officials responsible for the Capitol commission. Two such paintings exist today, one in the Smithsonian Institution's National Museum of American Art and the other in the Gilcrease collection (plate 39).

These paintings represent the epic of national expansion with the pioneer families cresting their final barrier, the California Sierras, and gesturing into the setting sun that their destiny is now fulfilled. The bottom panel, depicting the Golden Gate, brings the viewer to the Pacific Ocean and the culmination of national hope and aspiration. The two oil studies are pleasantly uncluttered and freely painted while the finished mural suffers, as one critic exclaimed at the time, from being "of all his frantic compositions . . . the maddest."[33] The theme, however, was one that continued to find an appreciative American and European

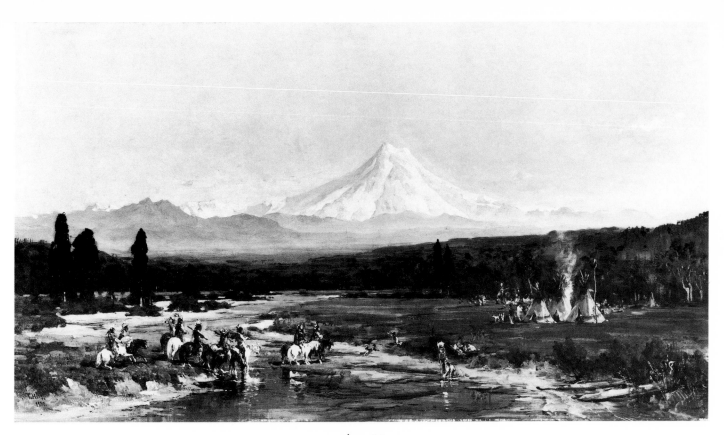

plate 54
Thomas Hill
Mt. Hood. *1880. Oil on canvas, 29 x 52". 0116.1591*

audience for the next two decades. Popularized in 1866 by the Currier and Ives lithograph by Fanny Palmer entitled *The Rocky Mountains—Emigrants Crossing the Plains,* the subject of the westward pioneer vanguard was much celebrated in literature and the visual arts. Here was the beginning of the end—reason for celebrating the cause for which Boone had first stepped into Kentucky. Neither the national optimism that it represented nor the pictorial iconography that resulted was overstated.

Albert Bierstadt, who during these years became America's most popular landscape painter, focused on this pioneering impulse in two major paintings completed in the late 1860s.[34] Like Wimar and Leutze, Bierstadt had been born in Germany and returned there in the 1850s to study at the Düsseldorf Academy. His initial intention was to become a genre painter, a persuasion from which he was dissuaded by his attraction to the European countryside and later the grand silhouette of the Rocky Mountains. However, genre elements do appear occasionally in his mature work with some success.

Perhaps Bierstadt realized, and wisely so, that if he were to reach greatness as an artist he should avoid history painting, in which Leutze was already clearly acknowledged as supreme. He was nonetheless driven toward the grand statement,

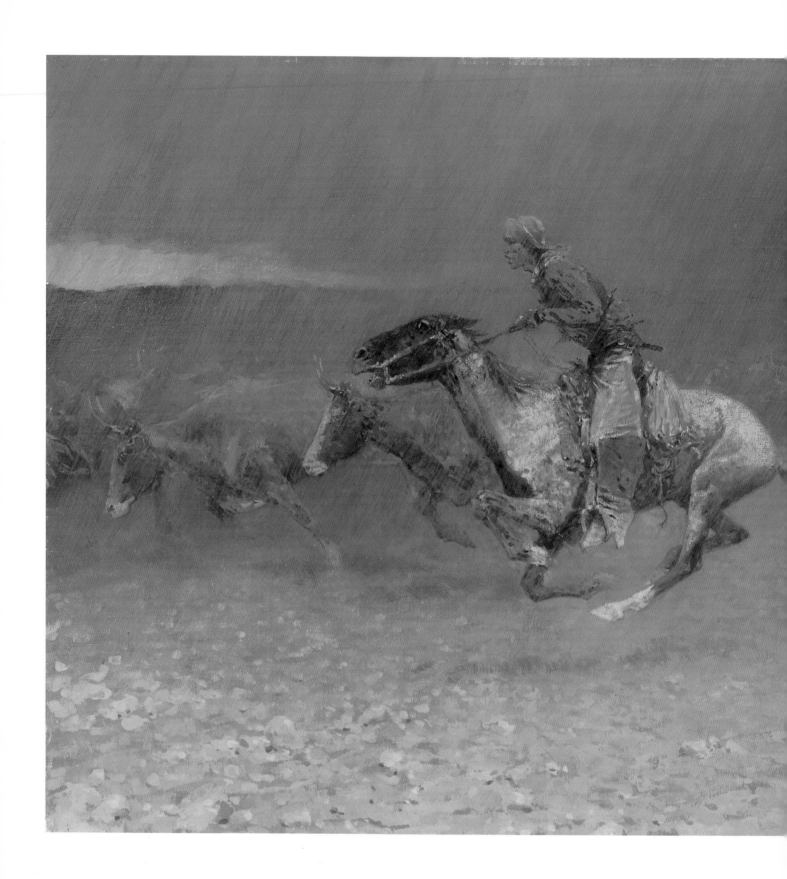

I think . . . man was never called on to do a more desperate deed then running in the night with long horns taking the country as it comes and with the cattle splitting out behind him, all as mad as the thunder and lightning above him, while the cut banks and [prairie] dog holes wail below. Nature is merciless.

Frederic Remington, from a letter to Ray Skofield (1908)

and if he could not succeed in the historical vein, he would find reward in the panoramic idiom. He left Düsseldorf with a taste for grandeur and theater, returning to America in 1857 prepared to desert the contemplative moods of the Hudson River Valley for the adventure and lure of the West. Two years later, accompanied by Colonel F. W. Lander, he was painting in the Wind River Range in the Rockies.

With the success in 1863 of his resulting showpiece, *The Rocky Mountains*,[35] Bierstadt was convinced that his choice of subject had made sense. That same year he ventured farther west to California, where he and his traveling companion Fitz Hugh Ludlow spent six weeks in Yosemite. From what was known as Inspiration Point, Ludlow viewed the valley and recounted the sublimity of the experience shared with the artist:

> *I hesitate now, as I did then, at the attempt to give my vision utterance. Never were words so beggared for an abridged translation of any Scripture of Nature. We stood on the verge of a precipice more than three thousand feet in height,—a sheer granite wall, whose terrible perpendicular distance baffled all visual computation.* [36]

plate 57
William Henry Jackson
California Crossing, South Platte River. *1867. Oil on canvas, 22 x 34". 0136.1208*

Bierstadt's view is surprisingly naturalistic, given the awesome regard with which his companion confronted the scene (plate 40). It speaks of the quiet reverie that one might experience upon confronting the Creator's ideal natural statement. Here was, as art historian Barbara Novak explains, a notion of the West as a "natural church," and as he sketched the view, Bierstadt labored in what Ludlow regarded as a "divine workshop."[37] The small size and fresh palette suggest that the painting may have been produced on the site.

More characteristic of Bierstadt's mature style is the painting *Sierra Nevada Morning* (plate 43). Proving him to be a virtuoso of atmospheric effect and baroque highlights, this work also accomplished an important psychological effect. The grandeur of the Western landscape as expressed in such lavish panoramas could remove the viewer from the mundane realities of an increasingly industrial environment. Man need have no presence in such scenes—the land alone could represent a singularly national, timeless glory that no human activity would enhance.

It was, in fact, the prevention of human exploitation of frontier lands that brought America's second great Western landscapist, Thomas Moran, to the fore. As a result of some evocative illustrations he had made for *Scribner's Monthly*,

His art was masculine and agressively modern and
it had, in an unusual measure, the qualities of its
defects. It was conceived without any thought of
pleasing a diletante taste; on the contrary, there
may have been a touch of the juvenile willingness
to shook the tradition-bound mind.

Unidentified, from Frederic Remington Obituary (1909)

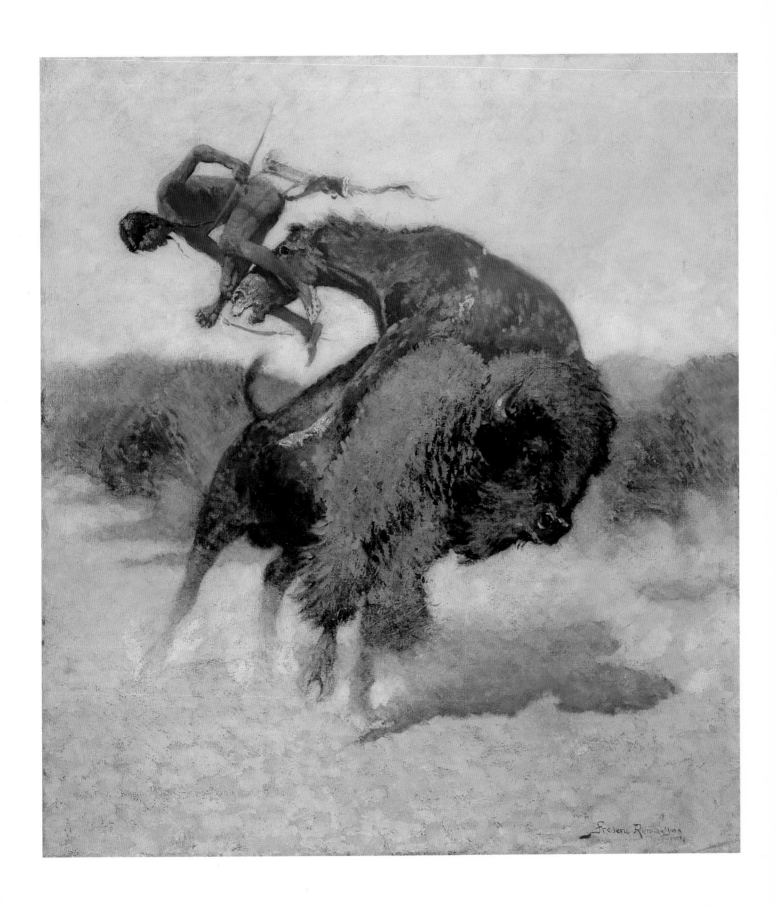

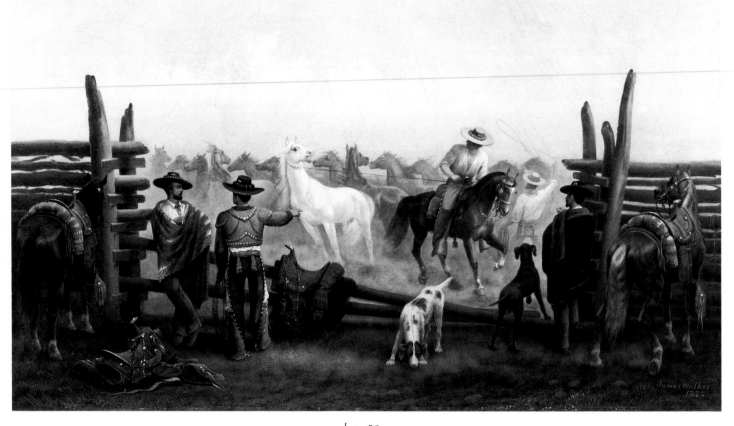

plate 59
James Walker
Gauchos in a Horse Corral. *1877. Oil on canvas, 20 x 36". O126.1480*

which revealed the splendors of the Yellowstone area as copied from the crude pencilings of two earlier explorers, Moran was allowed to join the 1871 Hayden Survey. The pictorial fruits of his journey, a set of brilliant watercolors (field studies for such studio-finished works as *The Grand Canyon of the Yellowstone* [plate 44] and *Tower Falls* [plate 49], helped in persuading Congress to set the area aside as a national park—the first in the United States and the world.

After seeing the commercial exploitation of Niagara Falls in the late 1820s, George Catlin had called for the formation of a "nation's Park"[38] beyond the Mississippi. Though this did not come about, the federal government, partly as a result of the popular clamor over Bierstadt's Yosemite paintings, ceded the Yosemite area to California for a state park. And now Moran was directly involved in the formation of Yellowstone National Park.[39]

Moran's artistic spirit was uplifted by this exposure to Yellowstone's wonders. As his daughter would later write, "to him it was all grandeur, beauty, color and light—nothing of man at all, but nature, virgin, unspoiled and lovely."[40] No more was necessary to inspire his career. The grand statement of nature as found in the West provided a clear but unspoken manifestation of divine providence. More im-

plate 60
Frederic Remington
Missing. *1899. Oil on canvas, 30½ x 51⅜". 0126.638*

portant for Moran, these wonders of natural form allowed the artist to explore ideas he had gleaned from J. M. W. Turner during his years of study in England. They also served to support his Ruskinian notions of idealized truth in the portrayal of nature (rather than the topographical precision of someone like Bodmer). And, finally, as these subjects were uniquely American, they served as cornerstones for Moran's fervent nationalism.[41]

As the Wind River Range had brought national acclaim to Miller, and later on a greater scale to Bierstadt, Yellowstone established Moran's reputation. In the summer of 1872, when Congress purchased Moran's seven-by-twelve-foot canvas, *Grand Canyon of the Yellowstone,* he was acknowledged as Bierstadt's clear rival. A short time prior to the sale, a newspaper critic who saw the painting in New York made the following remarks alluding to that awakened rivalry:

We took it for granted, in our haste, that it was simply a new chapter in the old story. Another acre of canvas was to be spoiled in an attempt to prove that Nature, in constructing the American continent, had gone clean daft, and forgotten her own laws; somebody else was groaning and laboring over mountains that after all would turn out a ridiculous muss; some other

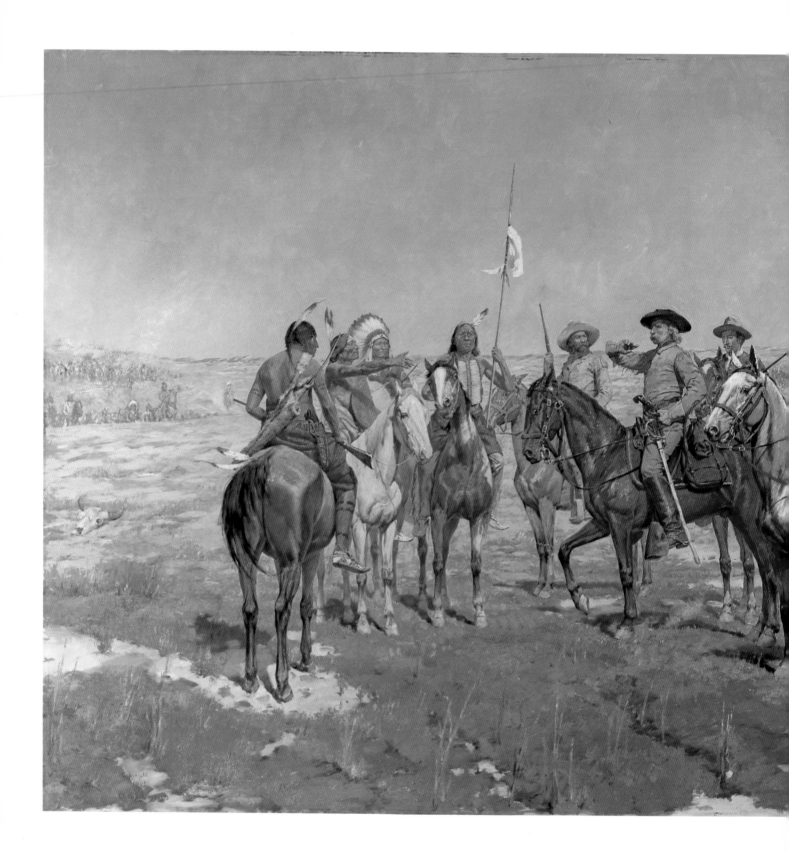

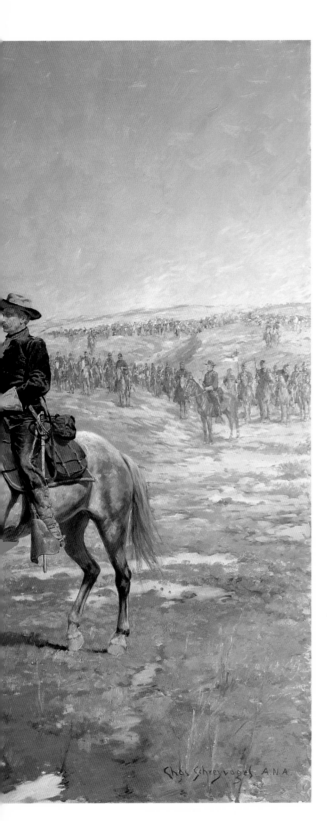

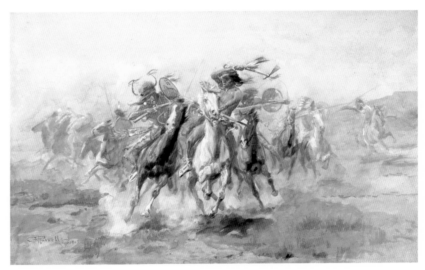

plate 61
Charles C. Schreyvogel
Custer's Demand
1903. Oil on canvas, 54 x 79". 0127.1254

If the painting is in an unusually quiet key for Schreyvogel, it is none the less characteristic of him in many details of technique. The group is admirably composed and, while it is historical, each figure, military or Indian, being a portrait, it is interesting as a mere picture aside from its historical value.

From the New York Herald *(1903)*

plate 62
Charles Marion Russell
When Sioux and Blackfeet Meet
1903. Watercolor on paper, 16½ x 27¼". 0237.1448

The picture "Counting Coup" and reproduced later under the caption "When Sioux and Blackfeet Meet," shows how Charlie's friend, Chief Medicine-Whip of the Bloods, got his name by riding in among the Sioux and hitting the Sioux medicine-man with his quirt.

Austin Russell, from Charles M. Russell, Cowboy Artist *(1957)*

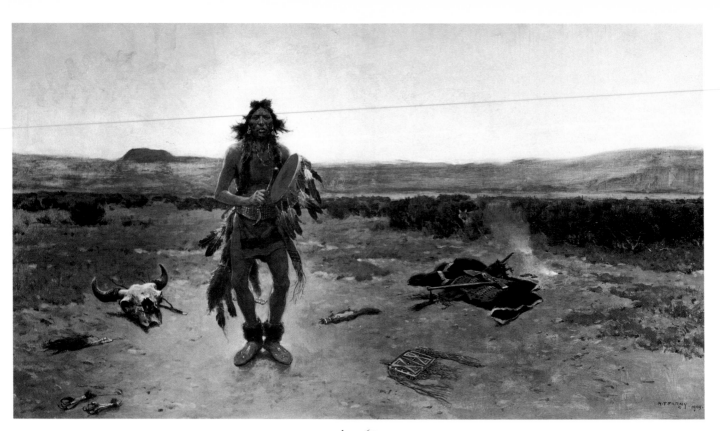

plate 63
Henry F. Farny
The Sorcerer. *1903. Oil on canvas, 22 x 40". 0127.1225*

mighty landskip was to be boiled down to academic glue in a Düsseldorf saucepan. . . . The people who came to see this picture came from curiosity or interest and the picture kept them there by its own intrinsic truth, sublimity, and beauty. Next to Church's "Niagara"—for to that noble picture the first place must long be given—next to Church's masterpiece, Mr. Moran's "Great Canyon of the Yellowstone" will, we are sure, be received by the best judges in America as the finest historical landscape yet painted in this country.[42]

Moran returned to the West year after year to gather new inspiration and material. As a result of his second visit to Yellowstone in 1892, he produced a number of highly sublime renditions of features in the park. One huge oil of the Lower Falls, even larger than the canvas purchased by Congress, eventually came to rest in the Smithsonian Institution's National Museum (today the National Museum of American Art). A somewhat smaller version, nearly identical in perspective, coloration, and suffused handling of paint, is now part of the Gilcrease collection. Titled *Lower Falls, Yellowstone Park* (plate 47), the painting shows Moran's mature style. Bold contrasts of light and dark, rich earth tones vibrant with brilliant highlights, and an overall diffusion of form suggest a much less naturalistic interpretation than seen in his Yellowstone work of the previous decade.

The full force of this increased subjectivity and romanticism was reached at the turn of the century. During a trip to the West in 1900, Moran stood at the brink of the great Shoshone Falls of the Snake River. "Not since his first sight of the Yellowstone and the Grand Canyon had he been so stirred and thrilled," remembered his daughter. "It was beyond words magnificent."[43] The unharnessed powers of nature were concentrated into this one extraordinary scene and were later masterfully translated onto canvas in his studio. The riverbanks are as bastions, the clouds as harbingers of impending tempest, and the plummeting foam and water are rendered timeless in the silent strokes left by the artist's brush. This was a panorama as epic as the West itself, and it was aflood with the spirituality and emotion that ordained Moran as the chief prelate of the natural church.

Although American taste for Western landscape persisted through the end of the nineteenth century, it was primarily focused on the adaptive talents of Thomas Moran. Albert Bierstadt was less able to sustain an enthusiastic audience—his Wagnerian overtures continued to lose favor as the century waned. Interpreted as overstatement and unnecessary exaggeration, Bierstadt's vast panoramas suffered the indignities of critical disregard and popular indifference. A telling, though not necessarily final, blow came in 1889 when the American Selection Committee for the Paris Exposition opted to refuse Bierstadt's grand expression of apotheosis, *The Last of the Buffalo.*[44]

Despite the fact that Bierstadt was making a genuine effort at artistic lament for the tragic diminution of the bison herds of North America and the inevitable toll that loss would take on the Indian, the artist had not met the new challenge. What America—or at least the American jury for the Paris show—wanted was a simple,

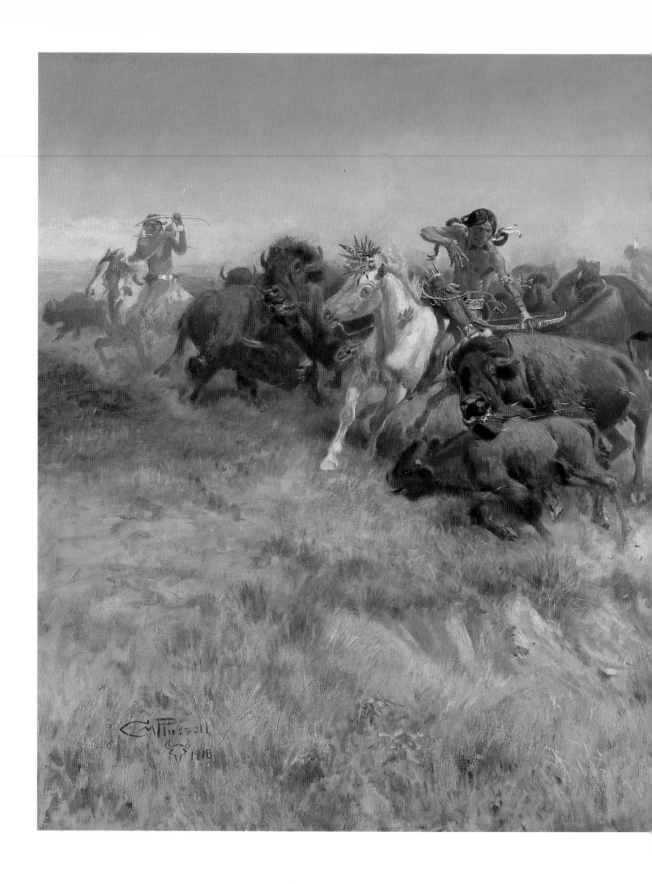

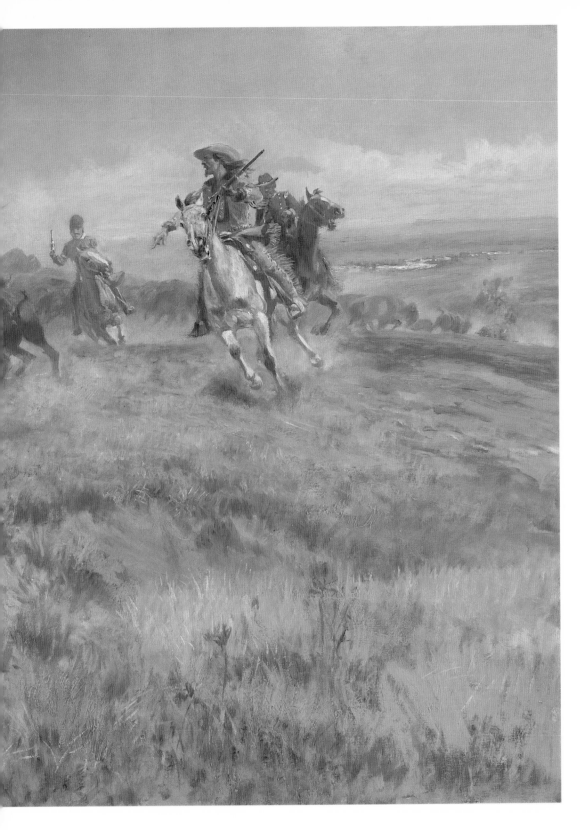

plate 64
Charles Marion Russell
Running Buffalo
1918. Oil on canvas,
29½ x 47½".
0137.2266

When the three started off from camp together, the Duke, Custer, and "Bill"—all large and powerful, and all hardy hunters—they attracted the attention and admiration of every one.

William Tucker, from His Imperial Highness the Grand Duke Alexis in the United States of America *(1872)*

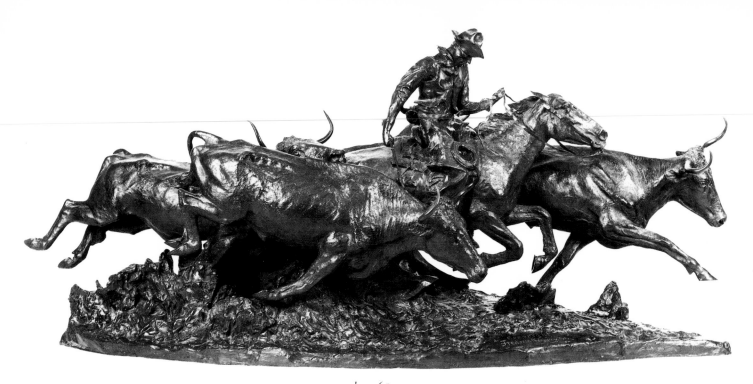

plate 65
Frederic Remington
The Stampede. *Copyright 1910. Bronze, 21¾ x 13⅞". 0827.54*

down-to-earth delineation of what was actually happening. The grand summary, as recounted by Bierstadt, was counter to the spirit of his times. The distinguished juror J. G. Brown called for painters to attend to "the things of interest they see around them, and pay no attention to the people who may call them commonplace."[45]

Two rather unlikely artists, Frederic Remington and Henry Farny, were admitted by the same jury and came home with the respectable accolades of a silver medal and an honorable mention. There existed between the two artists a strong commonality of interest and narrative persuasion. Each had an abiding fascination with the Far West, its people, and its saga. Each boasted a firsthand knowledge of the region and a devoted concern for its proper pictorial recording. And each was to win considerable acclaim in future years for his generous and talented concern with what he regarded as the unique element of the American scene found only in the West. Yet there the similarities ended. For Frederic Remington the world brimmed with masculine bravura and the boldest of Western adventure. For Farny there resulted a sensitive reckoning with the charm that made the frontier a special place, a humility for the grandeur of the West allied with an empathy for its diverse elements.

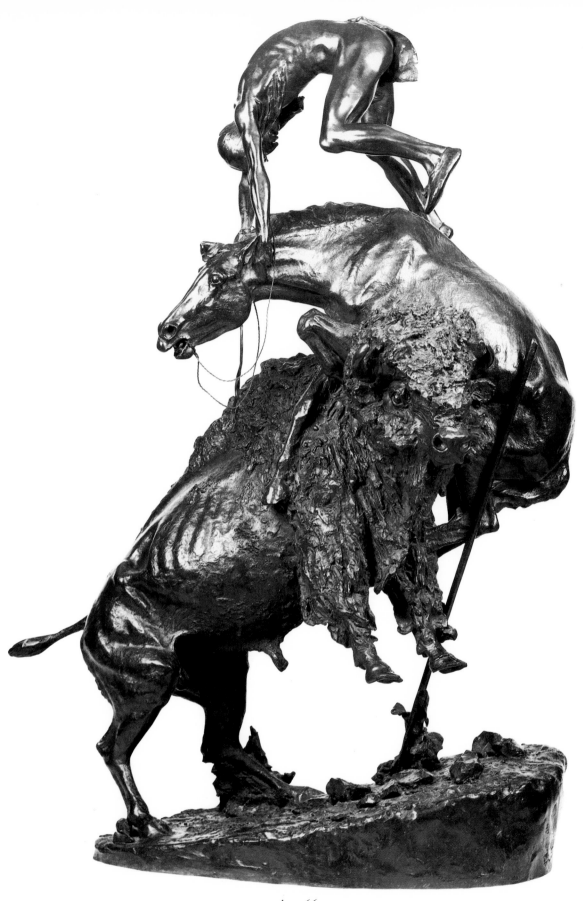

plate 66
Frederic Remington
The Buffalo Horse. *Copyright 1907. Bronze, 25⅞ x 11″. O827.51*

Russell had not only the wit to see the dual situation attached to any great moment, but he had, and with an ability Remington had never shown, the power to draw animals, horses, cattlemen in the mixed-up, tangled-up situations daily occurring in the wild unfenced West—situations no other artist has ever attempted.

Gutzon Borglum, from New York Herald Tribune *(1926)*

In people, he loved Human Nature. In stories, he loved Human interest. He ought to have been a Doctor. He wouldn't have had to use an Xray. He studied you from the inside out. Your outside never interested him. You never saw one of his paintings that you couldn't tell just what the Indian, the Horse and the Buffalo were thinking about.

Will Rogers, writing about Charles Russell (1929)

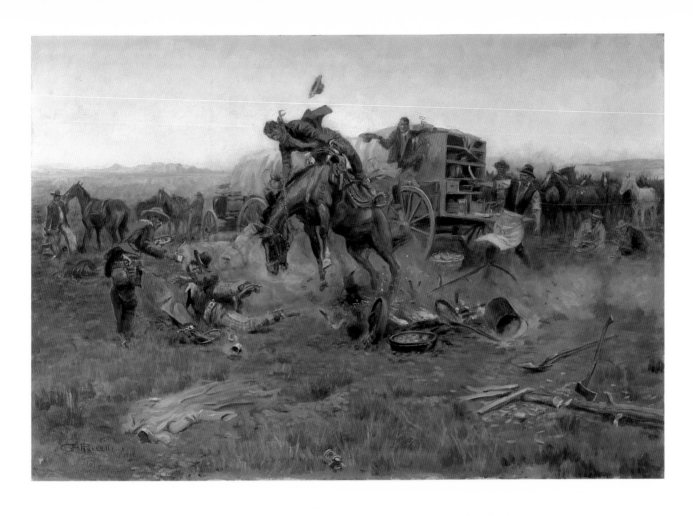

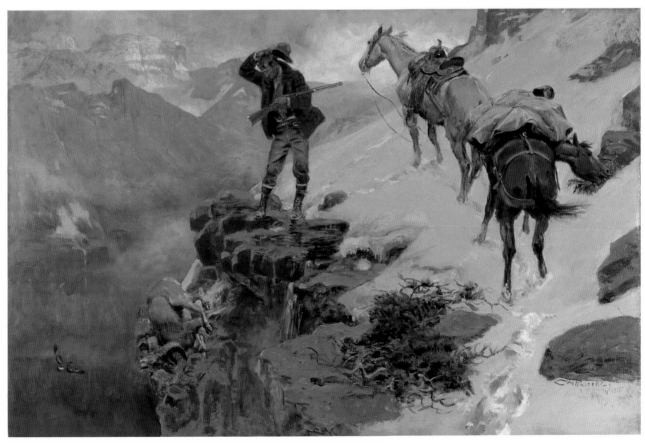

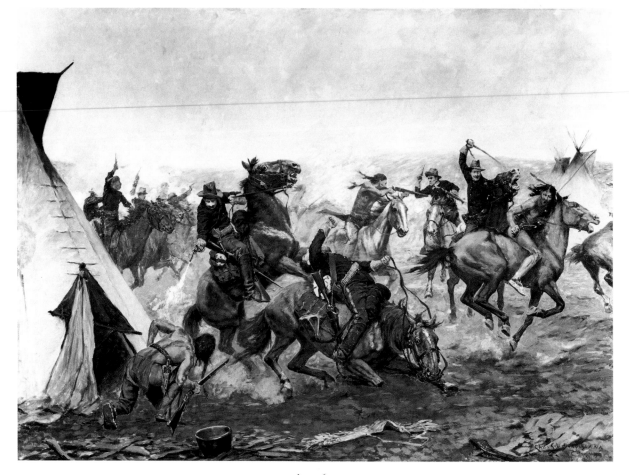

plate 69
Charles Schreyvogel
Attack at Dawn. 1904. Oil on canvas, 34 x 46". 0127.1255

Both Farny and Remington were determined in their schooling to become figure painters. This is ironic since Farny's most distinguished contribution to art comes not from his treatment of human form but from a sensitive depiction of the Western landscape, while Remington, in his mature years, wished to be recognized for his interpretation of Western light and scenery rather than history. Nonetheless, when Farny went off to study art in Düsseldorf in 1867 he bemoaned the fact that he had been stuck in the class of Herman Herzog, a landscape painter. He was much the better for such exposure.

Farny's painting *The Sorcerer* (plate 63) represents his clear vision of Indian mysticism. Dancing in solitary dignity among the symbols of his diminished but proud religious universe, this medicine man beats out a cadence in cushioned steps and taut drumbeats. They spell, as do the lingering embers of his fire, the waning chords of a fervent but final song.

A more vital interplay of Western land and figure is exemplified in Farny's later work *Fording the Stream* (plate 52). Taking full advantage of the union of sky and land, Farny creates a scene full of delicate light and color balance offset by the tension of human animation. In many of his most successful works, Farny employed

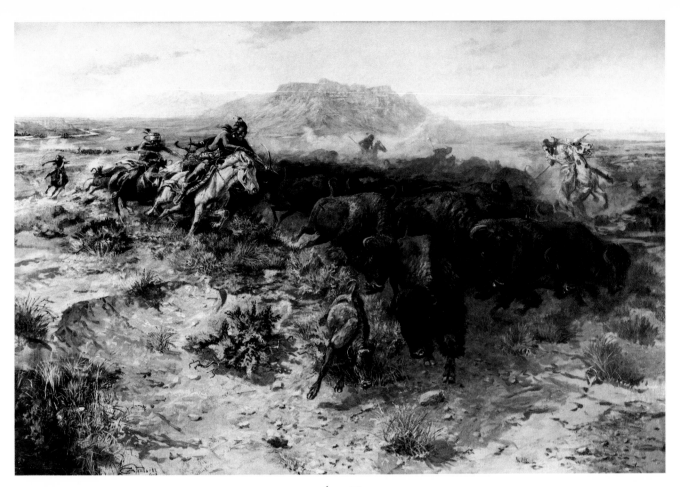

plate 70
Charles Marion Russell
The Buffalo Hunt. *1900. Oil on canvas, 48 x 72". 0137.2243*

a progression of horizontal planes to achieve a sense of receding depth. With the precise detailing of figures in the foreground, the artist achieved a remarkable spatial illusion. Combining open, free brushwork with muted tonalities, he imparted a singular mystery and glow to the scenes of everyday Indian life.

Remington, who is known for his blatant pictorializations of frontier struggle, came to similar conclusions in the early years of the new century. *The Stampede* (plate 55), painted in 1908, shows this artist as one who cherished the drama of Western life but knew also the mystery of nocturnal effects and thrived on the notion that the figure, prominent in the composition, would carry the full force of any artistic expression.

Remington's natural proclivity as a draftsman garnered him much success as a sculptor as well. His bronze *The Stampede* (plate 65) demonstrates that the linear force of his paintings could be articulated equally well in three-dimensional work. The vigor that Remington put into his brushwork during his later years translated directly into his sculpture. Exemplified in the companion pieces, *An Episode of the Buffalo Hunt* (plate 58), painted in 1905, and his bronze *The Buffalo Horse* (plate 66), this union of sculptural form and painted illusion is masterful.

Charles Marion Russell
Carson's Men
1913. Oil on canvas, 24 x 35½". 0137.2245

Christopher Carson, physically, was small in stature, but of compact frame-work. He had a large and finely developed head, a twinkling gray eye, and hair of a sandy color, which he wore combed back a la Franklin mode. His education having been much neglected in his youth, he was deficient in theoretical learning. By natural abilities, however, he greatly compensated for this defect. He spoke the French and Spanish languages fluently, besides being a perfect master of several Indian dialects. In Indian customs, their manners, habits, and the groundwork of their conduct, no man on the American continent was better skilled.

Dewitt C. Peters, Kit Carson's Life and Adventures . . . *(1874)*

Joseph Henry Sharp
Dividing the Chief's Estate
c. 1900. Oil on canvas, 27 x 40". 0137.388

In past years I have seen so many things and made studies that probably no other living artist ever saw, such as the Tobacco Dance, Graves, Burials, etc., that if I do not paint them no one ever will.

Joseph H. Sharp, El Palacio *(1926)*

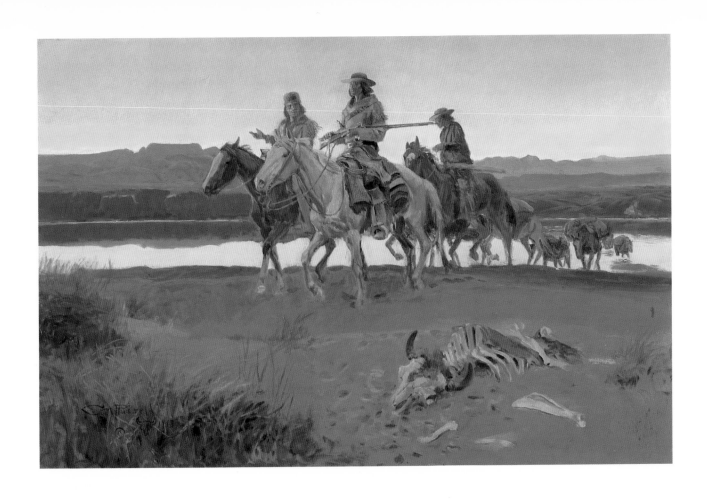

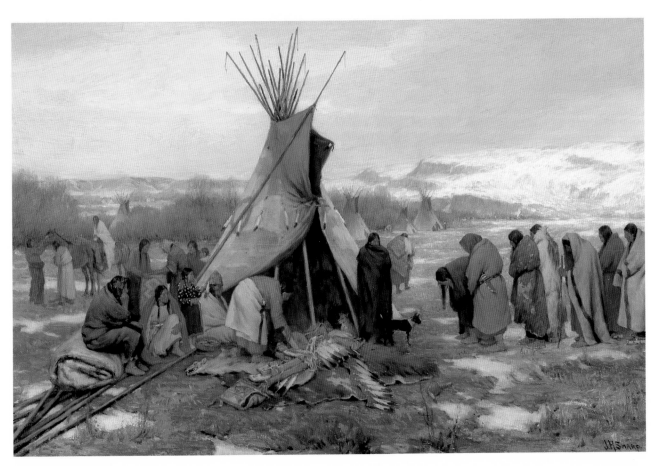

plate 73
Charles Marion Russell
Counting Coup. 1907. Bronze, 10¼ x 9⅜″. 0837.19

plate 74
Charles Marion Russell
The Buffalo Hunt. *1905. Bronze, 10½ x 12⅛". 0837.12*

Nowhere else in American art do we see such a direct and successful integration of pictorial expression. The theme, ironically, was strikingly similar to the one that put Bierstadt out of business—America was now ready for such a summary statement of the Indian demise. The Indian, flung to his doom by the animal that represented the sole promise of his livelihood, is bested by his singular and ephemeral source of survival. Together they pass out of existence. As a distant observer of this scene, Remington had waited out the tide and now profited by a taste for such mournful metaphor.

Though Remington had transcended the old school, his competition for recognition as the true painter of Western scenes was severely challenged by a rival as unlikely as he had been for Bierstadt. In 1900, a neophyte from Hoboken, New Jersey, named Charles Schreyvogel submitted a painting, *My Bunkie,* to the annual exhibition of the National Academy in New York. Remington had shunned the academy for several years because it had failed to recognize him as a full member. Now, an upstart had won their establishment endorsements and gained no less than their ultimate accolade, the coveted Hallgarten Prize.

plate 75
Ernest L. Blumenschein
Moon, Morning Star and Evening Star
1922. Oil on canvas, 50 x 40". 0137.2192

As a dance it is very beautiful; as a story or legend, it will always live; as a work of art, it is the American Indian at his top. The complicated weaving of these fifty or sixty figures, the intricate counter play of the "Chifonetes," (or clowns), the nobility of slow dance movement and the accompaniment of the singers and drummers produce a whole that, in my mind, equals any folk dance in the world.

Ernest L. Blumenschein,
from a letter to Thomas Gilcrease (1948)

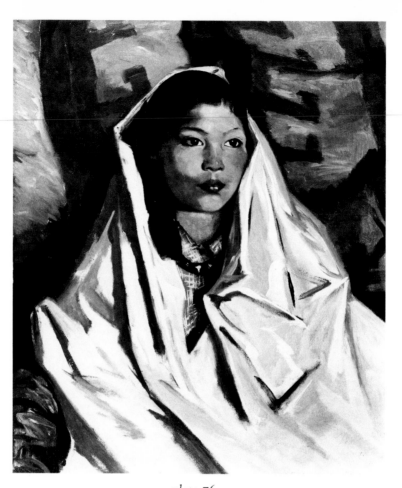

The controversy culminated in 1903 when Schreyvogel's painting *Custer's Demand* (plate 61) gained critical acclaim. A headline in *The Denver Republican* revealed the contest that was about to unfold: "How Schreyvogel, of 'My Bunkie' Fame, Paints Pictures of Western Life That Rivals [sic.] Frederic Remington."[46] Remington countered with the claim that Schreyvogel's details were lacking in accuracy. The contest proved Remington wrong, and his embarrassment was deeply felt. Time has proven Remington really had little to fear, for Schreyvogel's success was only surface deep, highlighted by the then glamorous Bavarian bravura. Remington's adaptation of Impressionist dictates as seen in *An Episode of the Buffalo Hunt* (plate 58) ultimately prevailed, leaving Schreyvogel to glory in the ephemeral praise of an unsophisticated press while Remington moved on to his true maturation as an artist.

Charles Russell, affectionately known in his day as the "cowboy artist," was less interested in esthetic combat. Member of a prominent St. Louis family, Russell earned his title as a Montana horse wrangler who painted and modeled as a sideline for the amusement of his fellow drovers. In 1892 he left the saddle for the studio, ultimately to become one of America's most renowned narrative artists.

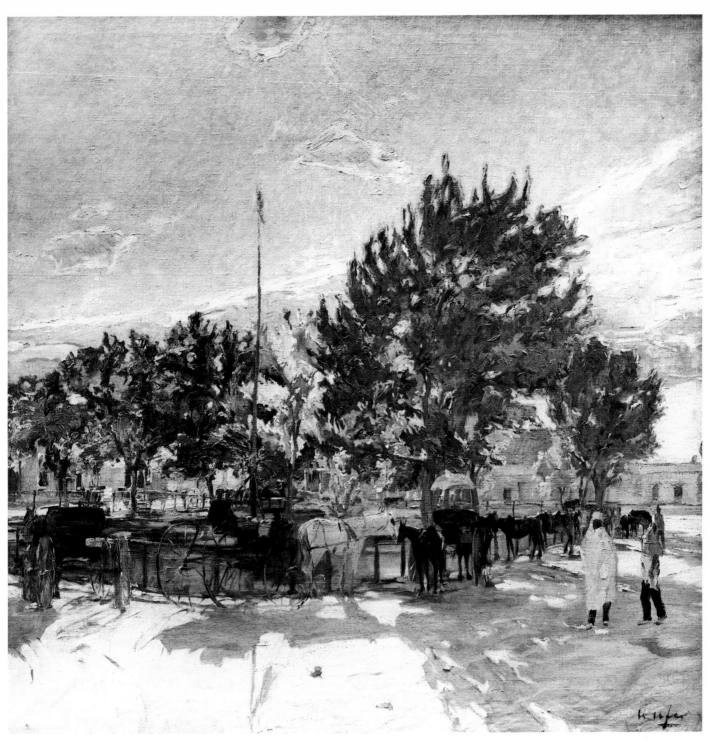

plate 77
Walter Ufer
Taos Plaza. *1928. Oil on canvas, 30 x 30". 0137.550*

Many of his larger canvases he did directly from nature without any preliminary sketches. There was always a horse or a group of horses in the picture, for, next to painting itself and the country in which he painted, the painting of horses was Berninghaus' metier.

Laura Bickerstaff, from Pioneer Artists of Taos *(1955)*

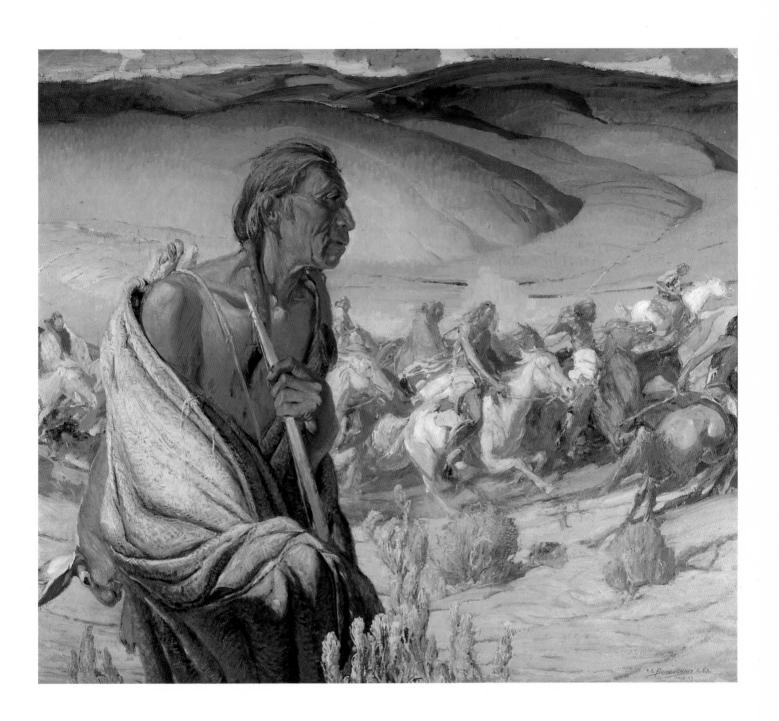

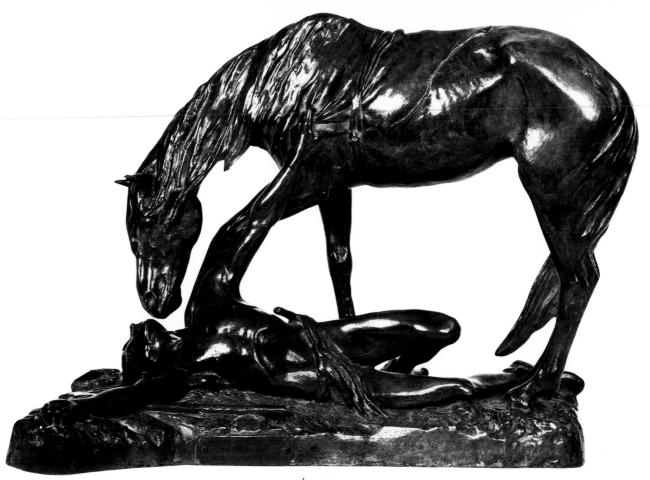

plate 79
John Gutzon de la Mothe Borglum
The Fallen Warrior. *c. 1891. Bronze, 10⅞ x 7½". 0876.125*

Russell has long been celebrated for unspoiled native genius. Known to have abandoned art training after only a few lessons as a teenager, he was thought to have evolved a uniquely personal style out on the range. He was, in fact, strongly influenced by the previous generation of St. Louis artists, particularly Carl Wimar. Russell had no need to traverse the Atlantic for exposure to the ateliers of Düsseldorf. All the necessary lessons in composition and coloration were right there in Wimar's canvases. This can be readily seen by comparing Russell's painting *The Buffalo Hunt* (plate 70) with the Wimar work of the same title (plate 41) completed nearly forty years before.[47]

In contrast to Remington and Schreyvogel, Russell felt sincere empathy with the Indians. His most revered subjects were drawn from the drama of Indian life and were generally offered up with their viewpoint in mind. *When Sioux and Blackfeet Meet* (plate 62) shows Russell to be a master of watercolor, a medium in which he excelled after the turn of the century. Like Remington, Russell also spent much of his energy exploring plastic forms of art. He was a natural sculptor whose works were generally smaller in physical stature than Remington's, but which often had more visual impact. His bronzes *Counting Coup* (plate 73) and

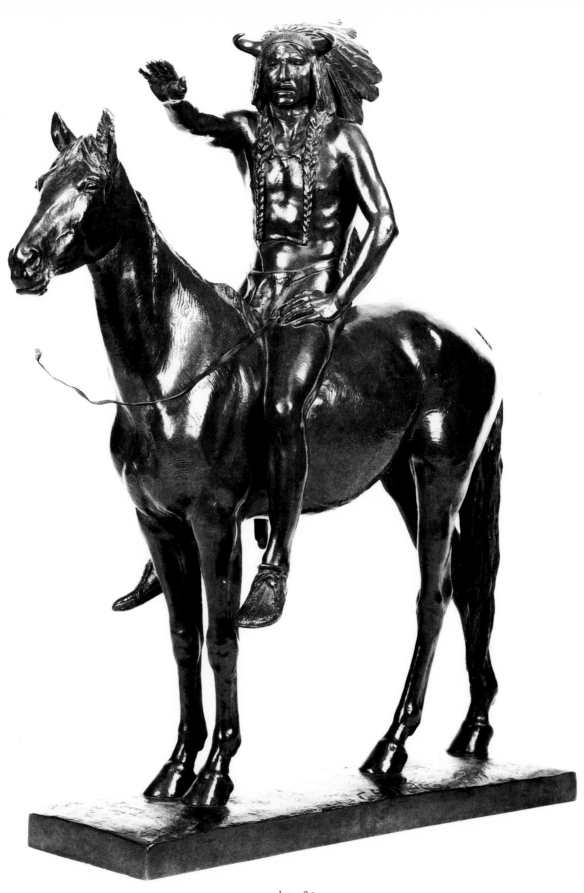

plate 80
Cyrus E. Dallin
The Medicine Man. *1899. Bronze, 17 x 5". 0826.72*

plate 81
Ernest Martin Hennings
Pueblo Indians
N.d. Oil on canvas, 45 x 50". 0137.2199

I constantly grew more enthusiastic over the West
for I was impressed with the possibilities for land-
scape and figure composition. New Mexico has al-
most made a landscape painter out of me, although
I believe my strongest work is in figures.

Reginald Fischer, from "E. Martin Hennings,
Artist of Taos," El Palacio *(1946)*

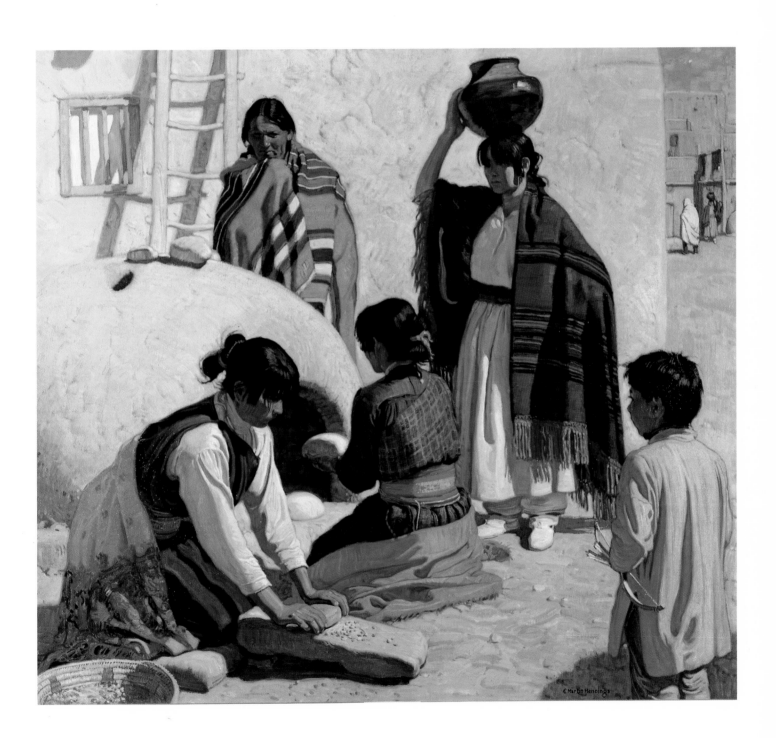

The Buffalo Hunt (plate 74) are exemplary of Indian themes translated into vital three-dimensional form.

In Russell's later career he became an extraordinary pictorial interpreter of Western anecdote. Whether recounting the sporting thunder of *Running Buffalo* (plate 64) with the Grand Duke Alexis and Buffalo Bill or sounding the clatter of horseshoes and cookware in *Camp Cook's Troubles* (plate 67), Russell captured the spirit of life on the prairies with marvelous facility and naturalness. Drawing inspiration from his own rich experience and the ample chapters of Western history, he earned a reputation as a raconteur in prose as well as paint. He loved stories that related man's foibles and glimpsed at the mysteries of nature. His insights into human behavior, combined with a warm sense of humor, elevated his anecdotal work beyond that of his Western contemporaries. Paintings such as *Meat's Not Meat 'Till It's in the Pan* (plate 68) are powerful yet simple statements of Russell's personal sensitivity to the ironic twists of fate.

Russell learned more than compositional hints from his St. Louis mentor, Carl Wimar. Russell admired the "gorgeous red sunsets and silvery moonlit rivers"[48] that he saw in Wimar's work displayed at the old St. Louis Courthouse and the city's new art museum. This same opalescent glow finds its way into many of Russell's mature works. *Carson's Men* (plate 71) are silhouetted against such a twilight backdrop as they ride into history through Russell's painting.

The secondary extension of Düsseldorfian tenets through Russell's work was countered by those of another artist who shared for a while Montana as a studio. Joseph Henry Sharp painted among the northern plains tribes during the first decade of the twentieth century. Owing his debt to Gustave Courbet and the realist tradition of Munich, Sharp avoided the anecdotal while striving for a monumental interpretation of ordinary scenes. Nature and life were to be painted rather than beautified in Sharp's mind, and he set to the sometimes somber task by utilizing the Crow, Cheyenne, Sioux, and Blackfoot as subjects.

Such paintings as *Dividing the Chief's Estate* (plate 72) reveal Sharp's propensity during his Montana years to paint rather dark pictures with ordinary themes. His brushwork is free and sure, though it never reached the full bravura of his fellow artists from the Munich classroom, Frank Duveneck and William Merritt Chase. Sharp's figures are boldly massed within the composition, which is refreshingly devoid of the superfluous symbolic element seen in such works as Henry Farny's *The Sorcerer* (plate 63).

After Sharp moved to Taos in 1912 and became part of the burgeoning art colony there, his style changed somewhat. His paintings, in design and color, began to take on the formal decorative elements of the Southwestern Indians who served as his models. In all his work, however, there is a prevailing quiet—an unspoken regard for the native cultures of the West.

The patterns of New Mexico's landscape and the Pueblo people's activities, architecture, and costume drew many painters to Taos in the second decade of this century. Ernest Blumenschein had met Sharp as an art student in Paris during the mid-1890s and been encouraged by him to come see the West. When Blumenschein eventually followed Sharp to Taos, he found a richly untapped source of in-

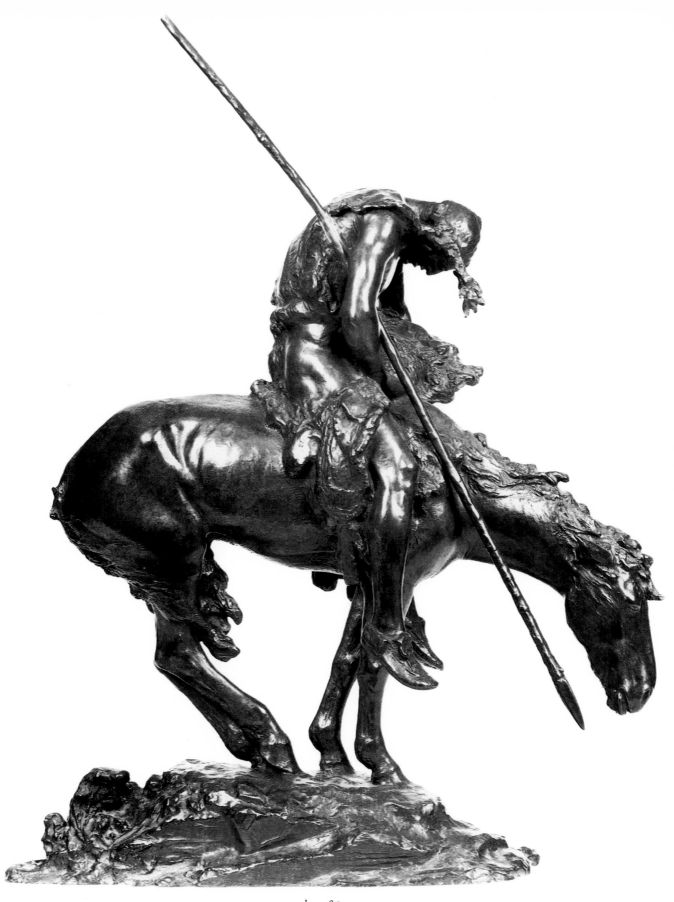

plate 82
James Earle Fraser
End of the Trail. *1918. Bronze, 36¾ x 8½". 0827.146*

plate 83
Walter Ufer
Hunger
N.d. Oil on canvas, 50½ x 50¼". 0137.2196

I choose my motifs and take my models to my motifs. I design the painting there. I do not make any small sketches of my models first but put my full vitality and enthusiasm into the one and original painting.

Walter Ufer,
from "Paintings of the West," El Palacio *(1920)*

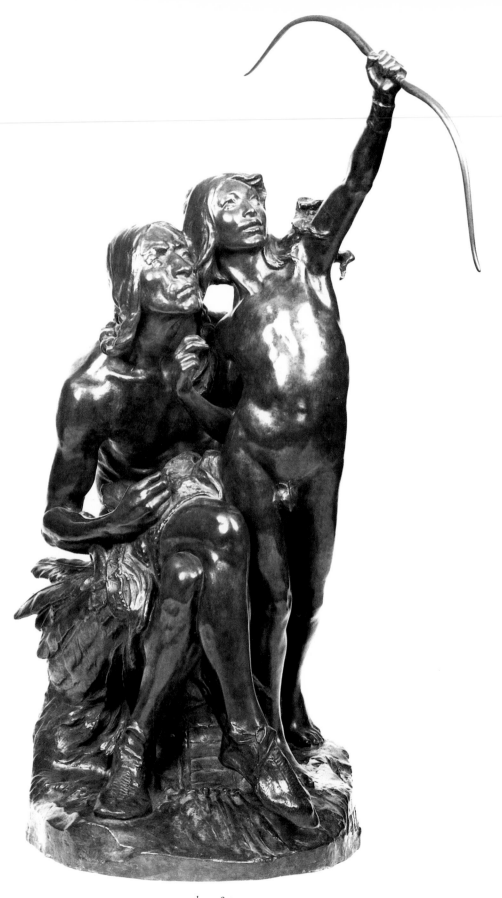

plate 84
Hermon Atkins MacNeil
The Sun Vow. *1889. Bronze, 28 x 14½". 026.103*

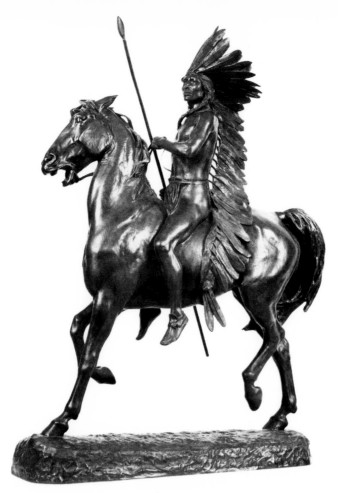

plate 85
Alexander Phimister Proctor
The Indian. 1898. Bronze, 40⅛ x 9⅛". 0876.79

spiration. "Sharp had not painted for me the land or the mountains and plains and clouds," he later wrote. "No artist had ever recorded the New Mexico I was now seeing."[49]

Blumenschein's canvas *Moon, Morning Star and Evening Star* (plate 75) is a boldly decorative interpretation of the life he found and the natural elements that abounded in the Southwest. In this "compressed stylization of Indian symbol and mystic ritual," as one observer has noted, "rhythms of associated movement carry across and through the design, binding the unit with a continuous inner life of its own."[50] In his portrayal of the Taos Deer Dance, Blumenschein has reduced the Indians to elements of pattern—they are lost entirely to their symbology.

In the paintings of Oscar E. Berninghaus, one of the other founding members of the Taos artist colony, the figure was never compromised for design. He cherished everything he saw around him and—even to a fault in some of his compositions—kept a clear eye for pictorial accuracy. His feelings about Taos offer an explanation of his special vision. As quoted in the St. Louis *Republic* in 1913, Berninghaus offered the painter's view:

This is splendid country for there are more varieties of atmosphere here than I have found in any place. . . . There are many varieties of sage and cactus

The thud of horses' hoofs upon the turf comes through the night and all hands at the station are alert and ready with a fresh mount for the Pony Express Rider who comes dashing in, his mochila loosened from the saddle, ready to leap from his pony. There is time for but a hurried word or two as he throws the mochila over the saddle of his fresh horse which is raring to go. A flying leap, a cloud of dust and he is again on his way.

Frank Tenney Johnson,
from unpublished notes on paintings (1927)

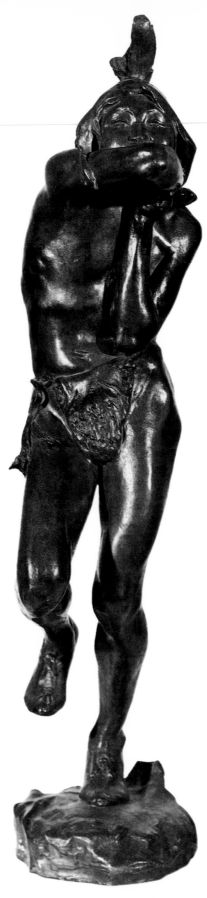

plate 87
Hermon Atkins MacNeil
A Primitive Chant. *1909. Bronze, 22¾ x 6". 0827.104*

for background, according to the elevation you choose. The Taos Indians are a splendid type; in fact the best I've seen. [51]

Berninghaus's affection for the Indians and their horses is seen in his painting *Too Old for the Rabbit Hunt* (plate 78). He also enjoyed painting historical scenes, a preoccupation that he shared with only one other of the six founding members, W. Herbert Dunton.

For Ernest Hennings and Walter Ufer, the patterns of Indian life translated directly into painted form. The Indian forfeits his role as an active participant in the flow of nature in Hennings's painting *Pueblo Indians* (plate 81) and becomes a decorative centerpiece—a colorful yet passive element used as a compositional motif rather than a cultural emblem. Ufer, who is known for his dramatic compositions, spent a good part of his time searching the Taos area for motifs that might result in great pictures. The somber symbolism of his painting *Hunger* (plate 83) is contrasted with the brilliantly invigorated scene of sunlit *Taos Plaza* (plate 77).

As Ufer was attracted to the prodigious brilliance of New Mexican sunlight, the California painter Frank Tenney Johnson explored nocturnal moods. With muted tones and bold brushwork he breathed life into the history of the West. Like his contemporaries Dunton and Berninghaus, he extracted passages from the past for such works as *The Pony Express* (plate 86). While there was symbol in Ufer's work, there was magic in Johnson's.

When Charles Russell died in 1926, art critics considered Johnson the sole survivor of the Western narrative tradition.

Russell knew the riders of the Northwest, but Russell is dead. Remington knew the cowboy and his mount and the whole story of the Old West; but Remington is dead. When Johnson is gone, the last of this trilogy of the trail and the range will have passed. As a painter of nocturnes, Frank Tenney Johnson is the peer of any artist that ever came out of the West. Russell and Remington could paint the sunlight, but when the twilight shadows began to fall they . . . withdrew. . . . Perhaps Frank Tenney Johnson is a poet who sings in color. . . . He possesses the secret of color, of light and shade, of technique and composition. [52]

Given Johnson's fascination with the poetry of color and light, it is surprising that he painted few, if any, pure landscapes. The backdrops in his paintings are usually generic, though sometimes monumental, almost baroque. His New York contemporary William R. Leigh explored both the figurative and the landscape disciplines. On his first trip into the Southwest in 1906 Leigh visited the Laguna Pueblo. It was in that setting that he found his initial inspiration and consummate challenge. "At last I was in the land where I was to prove whether I was fit—worthy of the opportunity—able to do it justice—or just a dunderhead." [53]

Although not technically his equal, Leigh shared much of the vision and philosophy of Thomas Moran. He felt, as did Moran, that the grandest expressions

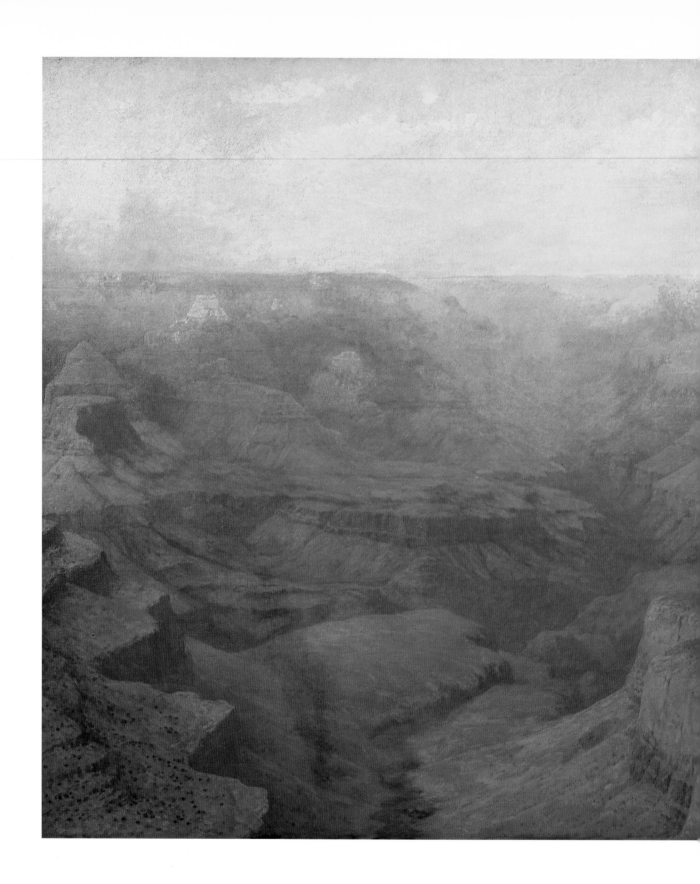

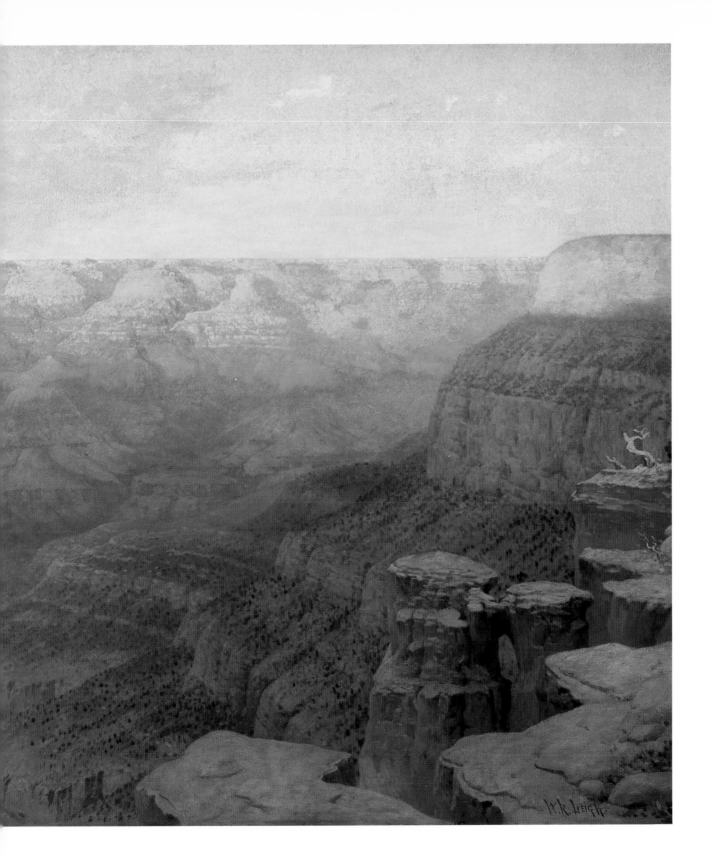

plate 88
William R. Leigh
Grand Canyon of the Colorado
c. 1908. Oil on canvas,
32⅛ x 57".
0137.714

Before me the stupendous chasm yawns, winding
into hazy indistinctness to right and left, entrancing,
frightful. The light borrowed from the sun makes
everything appear unreal and ghostly as itself,
yet all is visible.

William R. Leigh, from unpublished impressions (c. 1908)

of nature made the grandest pictures. The *Grand Canyon of the Colorado* (plate 88), which resulted from studies taken in Arizona between 1906 and 1908, proved this dictum true and set him beside Moran in another way as well. He wished, through his choice of subjects and his approach to painting landscapes, to produce an art that was uniquely American. In 1902 Moran had expounded on similar beliefs in a booklet titled *The Grand Canyon of Arizona:*

> *Before America can pretend to a position in the world of art it will have to prove it through a characteristic nationality in its art; and American artists can only do this by painting in their own country; making use of all the technical skill and knowledge they have acquired in the schools of Europe, and the study of the art of the past. There is no phase of landscape in which we are not richer, more varied and interesting than any [other] country in the world.* [54]

In fact, most of the artists discussed in this book considered themselves to be making a uniquely American contribution to the world of art. From George Catlin, who fought to preserve an image of the first American, to Charles Deas, whose Western subjects carried a "peculiar 'native American' zest," [55] to Frederic Remington, who was considered by Theodore Roosevelt to be a national treasure—they all were quintessentially American in their reverence for the West and in the artistic skills they employed to impart their message. With regionalist fervor Oscar Berninghaus, before his death in 1952, claimed that those of the Taos colony had done much to bolster a national art form:

> *From it . . . will come a distinctive art, something definitely American— and I do not mean that such will be the case because the American Indian and his environment are the subjects. But the canvases that come from Taos are as . . . American as anything can be. We have had French, Dutch, Italian, German art. Now we must have American art. I feel that from Taos will come that art.* [56]

In fact, from the West in general had come art that blossomed with a special American flowering of native genius and inspiration.

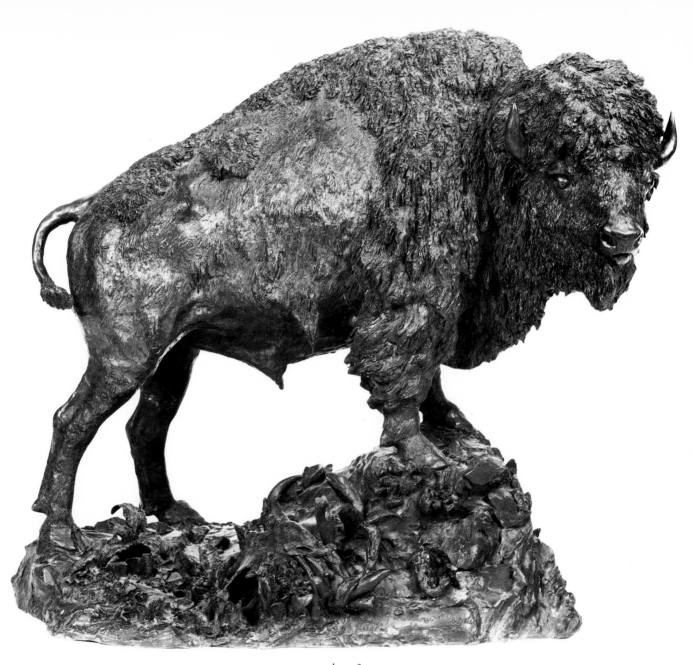

plate 89
Henry Merwin Shrady
Buffalo. 1899. Bronze, 13⅞ x 7⅛". 0827.134

NOTES

1. Henry T. Tuckerman, *Book of the Artists . . .* (New York, 1867), p. 425.

2. James Fenimore Cooper, "American and European Scenery Compared," in Washington Irving et al., *The Home Book of the Picturesque* (New York, 1852), p. 56.

3. Walt Whitman, *Specimen Days* (Brookline, Pa., 1971, reprinted from the 1882 Philadelphia edition), p. 95.

4. See Barbara Novak, *Nature and Culture: American Landscape and Painting* (New York, 1980), pp. 137–57; Patricia Trenton and Peter H. Hassrick, *The Rocky Mountains: A Vision for Artists in the Nineteenth Century* (Norman, Okla., 1983).

5. John Galt, *Life, Studies and Works of Benjamin West, Esq.* (London, 1820), p. 104.

6. The Gilcrease version of West's painting is a preliminary study for the finished work, an oil on canvas 75½ x 108¾ inches in the Joseph and Sarah Harrison Collection of the Pennsylvania Academy of the Fine Arts, Philadelphia.

7. Andrew J. Cosentino, "Charles Bird King: An Appreciation," *The American Art Journal*, vol. 6 (May 1974), p. 68.

8. William Dunlap, *The Arts of Design in the United States*, vol. 2 (New York, 1969; reprinted from the 1834 edition), p. 261.

9. James T. Flexner and Linda B. Samter, *The Face of Liberty* (New York, 1975), p. 67.

10. Thomas L. McKenney and James Hall, *History of the Indian Tribes of North America*, vol. 2 (Philadelphia, 1836), p. 4.

11. Rena N. Coen, "The Indian as the Noble Savage in Nineteenth Century American Art," unpublished Ph.D. dissertation, University of Minnesota, 1969, p. 65.

12. *St. Louis Beacon*, December 12, 1829.

13. *Missouri Republican*, August 15, 1834.

14. See *The Port Folio and New York Monthly Magazine* (March 1822).

15. Mabel Munson Swan, "The Unpublished Notebooks of Alvan Fisher," *Antiques*, vol. 68 (August 1955), p. 126.

16. Dunlap, *op. cit.*, vol. 2, p. 264.

17. "Catlin, The Painter of Indians," *The Arkansas Gazette*, September 23, 1834.

18. Tuckerman, *op. cit.*, p. 426.

19. Myrtis Jarrell and J. N. B. Hewitt, *Journal of Rudolph Friederich Kurz* (Washington, D.C., 1937), p. 3.

20. *Ibid.*, p. 2.

21. *Ibid.*, pp. 90–91.

22. Dawn Glanz, *How the West Was Drawn: American Art and the Settling of the Frontier* (Ann Arbor, 1982), pp. 21–54.

23. Coen, *op. cit.*, p. 115.

24. *Missouri Republican*, May 2, 1848.

25. Charles Lanman, *A Summer in the Wilderness* (New York, 1847), p. 15.

26. Tuckerman, *op. cit.*, p. 427.

27. See *The Emigration of Daniel Boone*, 1851, oil on canvas, in the collections of Washington University Gallery of Art, St. Louis, illustrated in Albert Christ-Janer, *George Caleb Bingham: Frontier Painter of Missouri* (New York, 1975), plate 159.

28. Tuckerman, *op. cit.*, p. 432.

29. See Francis S. Grubar, *William Ranney: Painter of the Early West* (Washington, D.C., 1962), p. 32.

30. *Ibid.*, p. 41.

31. Quoted in Robert Taft, *Artists and Illustrators of the Old West* (New York, 1953), p. 47.

32. "Leutze, The Artist," *Rocky Mountain News*, September 5, 1861.

33. James Jackson Jarvis, *Art Thoughts* (New York, 1869), p. 298.

34. These two works are titled *The Oregon Trail* (1869, The Butler Institute of American Art, Youngstown, Ohio) and *Immigrants Crossing the Plains* (1867, The National Cowboy Hall of Fame and Western Heritage Center, Oklahoma City, Okla.).

35. This painting, measuring 73½ x 120¾ inches, is now part of the collections of The Metropolitan Museum of Art, New York City.

36. Fitz Hugh Ludlow, "Seven Weeks in the Great Yo-Semite," *Atlantic Monthly* (June 1864), p. 746.

37. See Novak, *op. cit.*, p. 151.

38. George Catlin, *Letters and Notes on the Manners, Customs, and Condition of the North American Indians* (London, 1844), vol. 1, p. 262.

39. For discussion of the national park idea and its relationship to artists see Alfred Runte, *National Parks: The American Experience* (Lincoln, 1979), and J. Gray Sweeney, "The Artist-Explorers of the American West," unpublished Ph.D. dissertation, Indiana University, 1975.

40. Quoted in Thurman Wilkins, *Thomas Moran: Artist of the Mountains* (Norman, 1966), pp. 66–67.

41. For further discussion of these elements of Moran's aesthetics see Carol Clark, *Thomas Moran: Watercolors of the American West* (Austin, 1980), pp. 23–35.

42. "Mr. Thomas Moran's Great Canon of the Yellowstone," *New York Tribune*, May 3, 1872.

43. Quoted in Wilkins, *op. cit.*, p. 213.

44. Two versions of this painting exist—one in the collections of the Corcoran Gallery of Art, Washington, D.C., and the other in the Whitney Gallery of Western Art, Buffalo Bill Historical Center, Cody, Wyo.

45. J. G. Brown, "American Subjects for American Painters," *New York Herald*, 1889.

46. *The Denver Republican*, April 19, 1903.

47. For further discussion of Wimar's influence on Russell see Brian W. Dippie, "Two Artists from St. Louis: The Wimar-Russell Connection," in *Charles M. Russell: American Artist* (St. Louis, 1982), pp. 20–35.

48. Austin Russell, *C.M.R.: Charles M. Russell, Cowboy Artist* (New York, 1957), p. 40.

49. Quoted in "Ernest L. Blumenschein," *The American Scene*, vol. 3 (Fall 1960), p. 7.

50. Howard Cook, "Ernest L. Blumenschein: The Artist in His Environment," *New Mexico Quarterly Review* (Spring 1949), p. 22.

51. Quoted in "This Place Called Taos," *The American Scene*, vol. 15 (1974), p. 6.

52. Fred Hogue, "In Navajo Land," *Los Angeles Times*, March 24, 1928.

53. Quoted in D. Duane Cummins, *William Robinson Leigh, Western Artist* (Norman, 1980), pp. 86–87.

54. C. A. Higgins et al., *The Grand Canyon of Arizona* (Chicago, 1902), p. 86.

55. Tuckerman, *op. cit.*, p. 425.

56. Jane Slocum, "O. E. Berninghaus," *The American Scene*, vol. 3 (Fall 1960), p. 5.

CAPTION NOTES

Plate 1. Quoted in William Dunlap, *op. cit.*, vol. 1, pp. 92–93.

Plate 4. Thomas L. McKenney and James Hall, *op. cit.*, p. 204.

Plate 5. J. B. Patterson, ed., *Life of Ma-Ka-Tai-Me-She-Kia-Kick or Black Hawk . . .* (Boston, 1834), pp. 168–69.

Plate 8. Quoted in Alvin M. Josephy, Jr., *The Artist Was a Young Man: The Life Story of Peter Rindisbacher* (Fort Worth, 1970), pp. 65–66.

Plate 9. George Catlin, *Letters and Notes on the Manners, Customs, and Condition of the North American Indians*, vol. 1 (London, 1844), p. 2.

Plate 10. *Ibid.*, p. 85.

Plate 13. Sir W. D. Stewart and J. Watson Webb, eds., *Altowan* (New York, 1846).

Plate 14. Quoted in Marvin Ross, *The West of Alfred Jacob Miller* (Norman, 1951), p. 49.

Plate 17. *Alfred Jacob Miller Collection, op. cit.*, p. 165.

Plate 20. Quoted in John Francis McDermott, *Seth Eastman: Pictorial Historian of the Indian* (Norman, 1961), p. 81.

Plate 21. Thomas S. Donaho, *Scenes and Incidents of Stanley's Western Wilds* (Washington, D.C., 1854?).

Plate 24. "Pacific Railroad. Northern Route," *The Oregonian*, January 21, 1854.

Plate 28. Quoted in John Francis McDermott, "Charles Deas: Painter of Frontier," *Art Quarterly* (Autumn 1950), p. 299.

Plate 29. Quoted in Roderick Nash, *Wilderness and the American Mind* (New Haven, 1967), p. 63.

Plate 30. Quoted in John C. Ewers, *Adventures of Zenas Leonard Fur Trader* (Norman, 1959), p. 69.

Plate 33. Josiah Gregg, *The Commerce of the Prairies* (New York, 1844), p. 71.

Plate 36. Quoted in Robert Taft, *op. cit.*, p. 36.

Plate 39. Quoted in Dawn Glanz, *How the West Was Drawn: American Art and the Settling of the Frontier* (Ann Arbor, 1982), p. 78.

Plate 40. Quoted in Ralph A. Britsch, *Bierstadt and Ludlow, Painter and Writer in the West* (Provo, 1980), p. 45.

Plate 43. Henry T. Tuckerman, *Book of the Artists . . .* (New York, 1966; reprinted from the 1867 edition), p. 395.

Plate 44. Quoted in Carol Clark, *op. cit.*, p. 30.

Plate 47. Quoted in Amy O. Bassford, ed., *Home-Thoughts, From Afar: Letters of Thomas Moran to Mary Nimmo Moran* (East Hampton, 1967), pp. 119–20.

Plate 48. Quoted in Thurman Wilkins, *op. cit.*, p. 214.

Plate 51. Frederic Remington, *Pony Tracks* (New York, 1895), p. 83.

Plate 52. Edward F. Flynn, "Something About the Career of the Eminent Cincinnati Artist," *The Cincinnati Commercial Gazette*, March 14, 1893.

Plate 55. Frederic Remington, letter, December 12, 1908, in *Gilcrease Collection*, Thomas Gilcrease Institute of American History and Art, 3827.738.

Plate 58. Frederic Remington unidentified obituary, 1909, collection of the author.

Plate 61. "Another Frontier Painting," *New York Herald*, April 19, 1903, p. 9.

Plate 62. Austin Russell, *op. cit.*, p. 75.

Plate 64. William Tucker, *His Imperial Highness The Grand Duke Alexis in the United States of America During the Winter of 1871–1872* (New York, 1972; reprinted from the 1872 edition), p. 161.

Plate 67. Quoted in Gutzon Borglum, "A Westerner's Point of View," *Persimmon Hill*, vol. 11 (1982), p. 107.

Plate 68. Charles M. Russell, *Good Medicine: The Illustrated Letters of Charles M. Russell* (Garden City, 1929), p. 15.

Plate 71. DeWitt C. Peters, *Kit Carson's Life and Adventures . . .* (Hartford, 1874), p. x.

Plate 72. Quoted in Mary C. Nelson, "Joseph Henry Sharp: Dedicated Observer," *American Artist*, vol. 42 (January 1978), pp. 94–95.

Plate 75. Quoted in Jeanne Snodgrass King, "On Blumenschein," *The Gilcrease Magazine*, vol. 20, p. 11.

Plate 78. Laura Bickerstaff, *Pioneer Artists of Taos* (Denver, 1955), p. 17.

Plate 81. Quoted in Mary Nelson, *The Legendary Artists of Taos* (New York, 1980), p. 103.

Plate 83. Quoted in Patricia Broder, *Taos: A Painter's Dream* (New York, 1980), p. 225.

Plate 86. Frank Tenney Johnson, "Notes on Paintings" (unpublished), March 4, 1927, in *Frank Tenney Johnson Manuscript Collection*, Buffalo Bill Historical Center, MS.12, Cody, Wyo.

Plate 88. William R. Leigh, "Impressions While Camping in the Grand Canyon of the Colorado" (unpublished), c. 1908, in *Gilcrease Collection*, Thomas Gilcrease Institute of American History and Art, Tulsa, Okla.

SELECTED BIBLIOGRAPHY

Baigell, Matthew. *Albert Bierstadt.* New York: Watson-Guptill Publications, 1981.

Baur, John I. H. *American Painting in the Nineteenth Century: Main Trends and Movements.* New York: Frederick A. Praeger, 1953.

Born, Wolfgang. *American Landscape Painting: An Interpretation.* New Haven, Conn.: Yale University Press, 1948.

Broder, Patricia Janis. *Bronzes of the American West.* New York: Harry N. Abrams, Inc., 1973.

———. *Great Paintings of the Old American West.* New York: Abbeville Press, 1979.

Carter, Denny. *Henry Farny.* New York: Watson-Guptill Publications, 1978.

Catlin, George. *George Catlin: Episodes from Life Among the Indians and Last Rambles.* Edited by Marvin C. Ross. Norman: University of Oklahoma Press, 1959.

———. *Letters and Notes on the Manners, Customs, and Condition of the North American Indians.* 2 vols. London: published by the author at Egyptian Hall, 1841.

Clark, Carol. *Thomas Moran: Watercolors of the American West.* Austin: University of Texas Press, 1980.

Coen, Rena Neumann. "The Indian as the Noble Savage in Nineteenth Century American Art." Ph.D. dissertation, University of Minnesota, 1969. Ann Arbor, Mich.: University Microfilms, Inc., 1970.

Coke, Van Deren. *Taos and Santa Fe: The Artist's Environment, 1882–1942.* Albuquerque: The University of New Mexico Press, 1963.

Cummins, D. Duane. *William Robinson Leigh, Western Artist.* Norman: University of Oklahoma Press and the Thomas Gilcrease Institute of American History and Art, 1980.

Curry, Larry. *The American West.* New York: The Viking Press, Inc., 1972.

Dippie, Brian W. *Remington and Russell.* Austin: University of Texas Press, 1982.

Ewers, John C. *Artists of the Old West.* 1965; rev. ed., Garden City, N.Y.: Doubleday & Co., 1973.

Fern, Thomas S. *The Drawings and Watercolors of Thomas Moran . . .* South Bend, Ind.: University of Notre Dame Press, 1976.

Flexner, James Thomas. *Nineteenth Century American Painting.* New York: G. P. Putnam's Sons, 1970.

Glanz, Dawn. *How the West Was Drawn: American Art and the Settling of the Frontier.* Ann Arbor, Mich.: UMI Research Press, 1982.

Goetzmann, William H., and Joseph C. Porter. *The West as Romantic Horizon.* Omaha, Neb.: Center for Western Studies, Joslyn Art Museum, 1981.

Hassrick, Peter. *Frederic Remington.* Fort Worth, Tex.: Amon Carter Museum of Western Art, 1972.

———. *The Way West: Art of Frontier America.* New York: Harry N. Abrams, Inc., 1977.

Hendricks, Gordon. *Albert Bierstadt: Painter of the American West.* New York: Harry N. Abrams, Inc., and Amon Carter Museum of Western Art, 1974.

Hoopes, Donelson F. *The Düsseldorf Academy and the Americans.* Atlanta, Ga.: The High Museum of Art, 1972.

Kane, Paul. *Paul Kane's Frontier.* Edited with a biographical introduction and a catalogue raisonné by J. Russell Harper. Austin: University of Texas Press for the Amon Carter Museum and the National Gallery of Canada, Ottawa, 1971.

Kinietz, W. Vernon. *John Mix Stanley and His Indian Paintings.* Ann Arbor: University of Michigan Press, 1942.

McDermott, John Francis. *Seth Eastman: Pictorial Historian of the Indian.* Norman: University of Oklahoma Press, 1961.

McShine, Kynaston, ed. *The Natural Paradise: Painting in America, 1800 – 1950.* Essays by Barbara Novak, Robert Rosenblum, and John Wilmerding. New York: The Museum of Modern Art, 1976.

Nash, Roderick. *Wilderness and the American Mind.* New Haven, Conn.: Yale University Press, 1967.

Novak, Barbara. *American Painting of the Nineteenth Century . . .* New York: Praeger Publishers, Inc., 1969.

_____. *Nature and Culture: American Landscape and Painting, 1825 – 1875.* New York: Oxford University Press, 1980.

Renner, Frederic G. *Charles M. Russell Paintings, Drawings, and Sculpture in the Amon G. Carter Collection.* Austin: University of Texas Press for the Amon Carter Museum of Western Art, 1966.

Ross, Marvin C., ed. *The West of Alfred Jacob Miller.* Norman: University of Oklahoma Press, 1951.

Rossi, Paul A., and David C. Hunt. *The Art of the Old West from the Collection of the Gilcrease Institute.* New York: Alfred A. Knopf, 1971.

Sweeney, J. Gray. "The Artist-Explorers of the American West 1860–1880." Ph.D. dissertation, Indiana University, 1975. Ann Arbor, Mich.: University Microfilms, Inc., 1975.

Taft, Robert. *Artists and Illustrators of the Old West, 1850 – 1900.* New York: Charles Scribner's Sons, 1953.

Trenton, Patricia. *Picturesque Images from Taos and Santa Fe.* The Denver Art Museum, 1974.

_____ and Peter H. Hassrick. *The Rocky Mountains: A Vision for Artists in the Nineteenth Century.* Norman: University of Oklahoma Press, 1983.

Truettner, William H. *The Natural Man Observed: A Study of Catlin's Indian Gallery.* Washington, D.C.: Smithsonian Institution Press, 1979.

Tuckerman, Henry T. *Book of the Artists.* New York: James F. Carr, Publisher, 1966.

Tyler, Ron, ed. *Alfred Jacob Miller: Artist on the Oregon Trail.* Catalogue raisonné by Karen D. Reynolds and William R. Johnston. Fort Worth, Tex.: Amon Carter Museum, 1982.

Wilkins, Thurman. *Thomas Moran: Artist of the Mountains.* 1966; 2nd ed., 1969. Norman: University of Oklahoma Press, 1969.

Woloshuk, Nicholas. *E. Irving Couse, 1866 – 1936.* Santa Fe, N.M.: Santa Fe Village Art Museum, 1976.

INDEX

*Numerals in italics indicate
the illustration of the work cited.*